LADYWOOD

DAY BY DAY

LADYWOOD

DAY BY DAY

N O R M A N B A R T L A M

The
History
Press

First published 2011

The History Press
The Mill, Brimscombe Port
Stroud, Gloucestershire, GL5 2QG
www.thehistorypress.co.uk

© Norman Bartlam, 2011

The right of Norman Bartlam to be identified as the Author
of this work has been asserted in accordance with the
Copyrights, Designs and Patents Act 1988.

British Library Cataloguing in Publication Data.
A catalogue record for this book is available from the British
Library.

ISBN 978 0 7524 5971 4

Typesetting and origination by The History Press
Printed in Great Britain

Contents

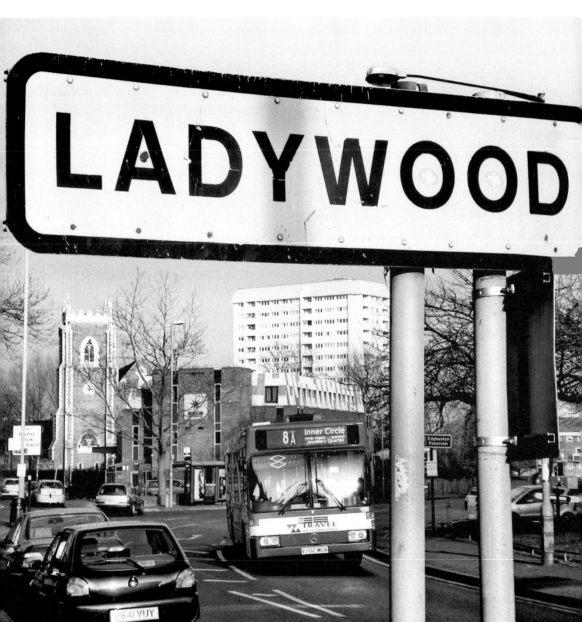

Introduction

'IN CONVERSATION'

The illustration below is a famous painting owned by Birmingham Museum & Art Gallery, entitled 'Conversation Piece on Monument Lane' and dates from about 1780. Compare the human activity with the 1963 photograph on page 9 entitled 'Conversation Piece with Headscarves on Monument Road', outside the Nags Head to be precise, and the 2011 view outside the present-day Oratory School, on page 10 entitled 'Conversation Piece in the Rain on Monument Road'.

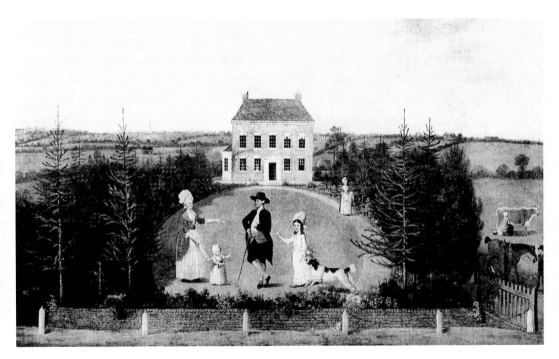

'Conversation Piece on Monument Lane', c. 1780.

The thing they've got in common is that people are meeting up to discuss what is happening and to comment on the changing face of the area. It is hard to imagine there being much for anyone to worry about in the 1780 picture, but there is a growing menace just visible in the distance. That enormous multi-storey structure could well be the folly, built twenty years earlier for Mr Perrott. Imagine the conversation:

'I said at the time we should oppose the building of such a structure, tall buildings have no place in Ladywood. There's enough space for houses, no need to build up.'

'Who does he think he is, looking down on us?'

'Now we've let them build one, they'll be building tall blocks all over the place.'

'No, be don't be daft, they'll never catch on.'

'That Plough & Harrow up the road is getting a bit big as well, attracting too many revellers on the way to the market, they were drinking until the early hours last night, their sheep were all over the place, frightening the deer . . .'

' . . . and the old dears weren't impressed either.'

'And that noise yesterday, those navvies are going to destroy this landscape if they get permission to carry on with that canal thing. Why, oh why we need it I don't know.'

'It'll speed transport up, and bring that dirty coal into town much quicker, but don't ask me what they'll do with it.'

'They must have money to burn!'

'That cut thing. It's not coming through my backyard.'

'We'll campaign to have it moved nearer to Spring Hill and up to town. I'll write to the *Bugle*.'

'That town is getting bigger by the day – it's only going to engulf us, things will only get worse.'

'My Norman's making drawings of what the area is like now, he says things might change if that canal comes in, he says we'll not know the place within a few years. In years to come people will marvel at his sketches and wonder at the bygone age.'

Fast forward to the 1960s scene:

'So, they're going to knock all our area down and start again.'

'I say we should oppose the destruction of the community.'

'That Norman Power bloke will help us.'

'I hear they're going to build loads of flats around here and put a great road right through the middle of us.'

'Better take a few piccies before it's all gone.'

'They will want to build tower blocks all over the place, you mark my words, our wench, I'm telling ya!'

'I bet they'll give 'em posh names and call them cathedrals in the sky, it'll help us to loik them, loik, ya know what I mean.'

'Don't be daft, they'll never catch on.'

'I'm sure I've heard that before!'

'Any road up, it won't bother us much, because we're being moved away from here to a new house in Northfield.'

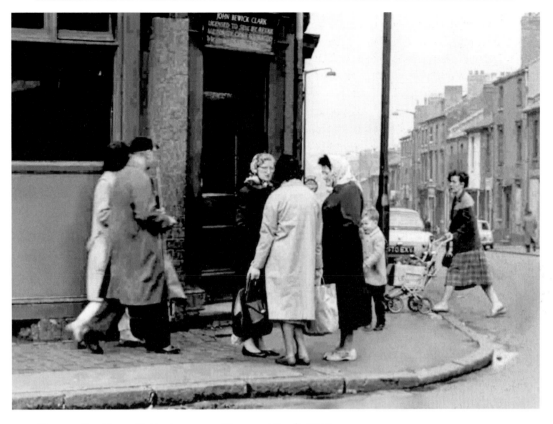

'Conversation Piece with Headscarves on Monument Road', 1960s.

'Hark at 'er, just 'cos her's got a new house with an indoor loo!'

'Mom an' dad are going to Acocks Green, next door are off to Kingstanding . . .'

'And her down the road with her nose in the air has got a house in Sutton.'

'She was always kippers an' curtains was that one.'

'So, as I was saying, all this redevelopment here won't affect us much because we won't be here!'

'Yeah, I suppose we'll all keep in touch and I'll get some new neighbours. I'm sure the ones on top of me and below me will be nice.'

'Our Norman's gone off to take a few more pictures, I don't know why, we will certainly remember this!'

'I haven't got time for that. I'm having trouble getting me lino up, it's stuck to the pantry floor.'

'Good idea though. I'd loik to take a few pictures before I go, shame I haven't got a camera!'

'Here, smile . . . (click) . . . oops, too late, here's the removal van.'

'Tara a bit.'

'See you soon.'

'See you soon she says . . . yeah, in forty years more like, when someone organises a reunion or does a book with our Norman's pictures in!'

Fast forward to 2010:

'That traffic island's a nightmare – they're talking about putting in more traffic lights, it's already like Blackpool illuminations at night!'

'Yeah, I was saying the last factory down the road is closing.'

'Yeah, but there's a few jobs going at the hotel that they're building.'

'They started to demolish that block up the road this morning.'

'I thought summat was happening because I saw Norman running up the Middleway with his video camera.'

'I hear there's a plan to redevelop the loop area.'

'Conversation Piece in the Rain on Monument Road', 2010.

Spring Hill, 1967 and 2011. Development in Ladywood his been incessant over the years.

'Oh, yeah, they've already demolished or closed too much stuff, like the swimming baths, secondary school . . .'

'At least the library's still here.'

'. . . and the folly is still standing, even if not much else is.'

'And don't forget all the small shops that used to be here.'

'That reminds me, that new Tesco has some offers on, must go.'

And so, in the twenty-first century there is a rich heritage and great deal of change to record. Sources of local history begin in the immediate family. How many people of a certain age have said: 'I wish I'd asked our mom about such and such'? or 'Dad never really talked about what he did during the war, and it didn't seem important when I was a kid, and now it's too late to ask him.' So, please ask now before it is too late!

How many of you have said: 'Time seems to go by so fast when you get older,' and 'things seem to change so fast these days.' Even, a ten-year-old has seen an enormous amount of change in their short lifetime, and many of these changes seem insignificant at the time, but when related to other past happenings they form a great timeline of history.

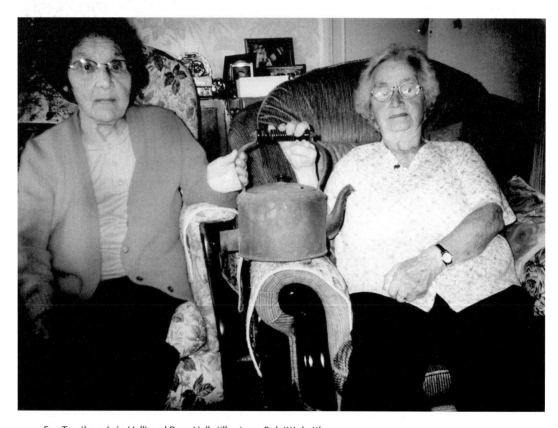

Eva Trentham (née Hall) and Rosa Hall still using a Bulpitt's kettle.

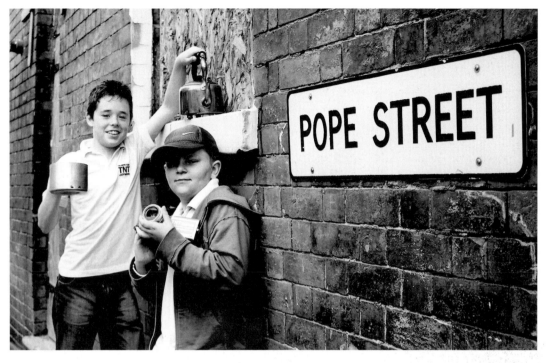

Youngsters from Ladywood's TNT News record the changing face of the area near the former Bulpitt's factory.

By way of example there is a new doctors' surgery on Ladywood Middleway. 'That was a pub until last month,' said one youngster. 'It was called the Eighteenth Hole,' said another. An older, but still young person added: 'It was The Squirrel before that.' When I told them it was called something else before that, it caused quite a discussion and next day the child returned to say she'd found out by asking her gran that it used to be called the Eagle & Ball. 'Nan used to go in every night when she was Mom's age and she lived in a block of flats behind it, but the flats aren't there anymore – what happened to them?' That led to the turning of pages in my books *Ladywood in Old Photographs* and *Ladywood Revisited*.

This Ladywood book is different from the previous ones in that it takes a unique approach to record the history of this great neighbourhood. It is a day-by-day, blow-by-blow account of events and happenings, presented in diary form, giving an account of something that happened on every date of the year.

This book also tries to avoid using photographs that have appeared in previous publications and tries to include many apparently individual stories and accounts from the 'ordinary' man in the street, including many forgotten episodes from our rich history. Such a huge collection builds up to a fascinating collection that reminds us all of the community in days gone by. Uniquely the book includes extracts from newspapers, magazines and school log books so hopefully, you will find something that appeals to you whatever your age.

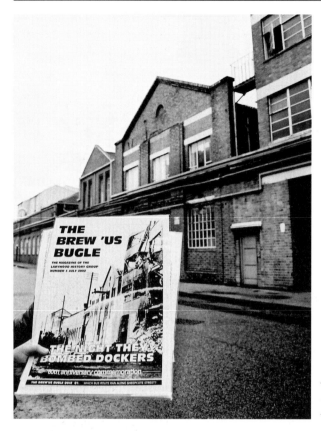

The magazine of the Ladywood History Group recalls the bombing of the Docker Bros factory in 1942.

If you would like to share your memories then in get in touch with the Ladywood History Group, and get a copy of our quarterly magazine, the *Brew 'Us Bugle*. We can be contacted at Ladywood Arts & Leisure Centre, 316 Monument Road, Birmingham, B16 8TR. You can email at brewusbugle@hotmail.co.uk

Ladywood Arts & Leisure Centre was once Ladywood School, which was built on the site of Beach Street and Freeth Street, next to the patch of grass where the baths used to be . . . but that's another story. Find what happened to the baths in the pages of this book!

Long live Ladywood! I hope you enjoy the book.

Norman Bartlam
March 2011

JANUARY

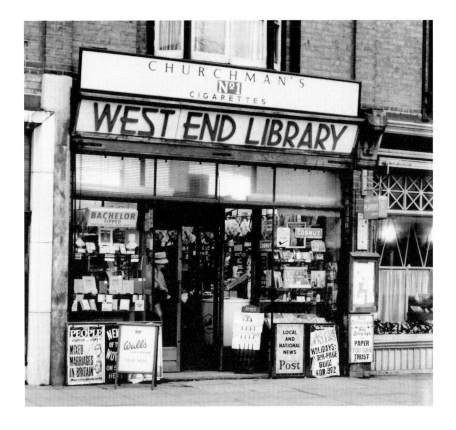

The West End Library newsagent, Hagley Road, near the Monument Road junction in January 1962.

1 JANUARY 1948

Michael Balcon, the Birmingham-born production chief at Ealing film studios, was awarded a knighthood. He was a former pupil of George Dixon School and used that name for one of his most well known creations, PC George Dixon in the 1948 film *The Blue Lamp*. This gave rise to the long-running BBC TV series *Dixon of Dock Green*.

2 JANUARY 1861

Arthur Ryland, the Mayor of Birmingham, announced, 'I do hereby certify that Messrs Ralph Heaton & Sons of the Mint are able to execute any amount of Coinage that may be required either by the British Government or any foreign state.' This endorsement was given to the near fifty-year-old company which made a mint out of their mint. The familiar Icknield Street premises opened in 1862 by which time Heaton's Mint was the largest private mint in the world. In 1918–19 they made 145 million pennies.

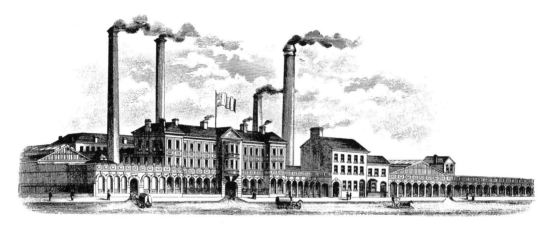

A nineteenth-century sketch of the Mint.

3 JANUARY 1966

'An angry caretaker said children are making one of the city's latest housing estates a slum,' reported the local press. Edward Gear, who was responsible for Charlecote Tower, Cregoe Street, was quoted as saying, 'Children break light fittings, smash windows, damage trees, spoil lawns with bicycles, carve on walls and wreck cars.' A housing department spokesman said, 'We usually get more vandalism near the city centre because the public passes through it more.'

4 JANUARY 1971

The full inner ring road was finally opened. At that time it was estimated that there were around 253,000 cars on Birmingham's roads.

5 JANUARY 1872

Death of Joseph Gillott, 73, a well-known pen maker. 'His nibs' traded from a huge factory at Graham Street in the Jewellery Quarter; the building still stands today. He married the sister of John and William Mitchell, who were at the time equally well-known makers of pens. The family carried on the business and it became part of British Pens in 1969.

6 JANUARY 1873

Surgeon Sampson Gamgee first raised the suggestion that everyone should work overtime for the hospitals on a particular annual Saturday afternoon, to be called Hospital Saturday. This new scheme called the Birmingham Hospital Saturday Fund was inaugurated on 15 March.

7 JANUARY 1893

The library was opened by the Lord Mayor Alderman Parker on 7 January 1893. The *Birmingham Daily Post* described it as: 'a work of architectural beauty', 'an admirable piece of work by architects Martin & Chamberlain' and 'an ingenious and economical disposal of space.' It was stocked with books valued at £500, but these were not available to loan until April. The library was initially used as a reading room.

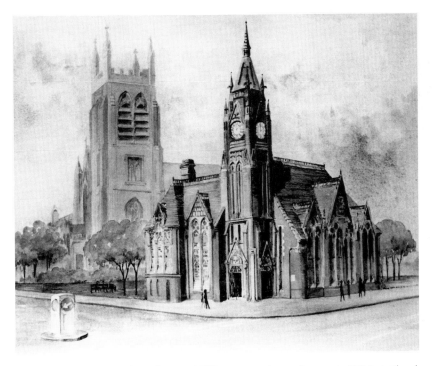

In 1972 a plan was devised to jack Spring Hill library up and move it nearer to St Peter's Church to make way for road widening. The plan was not carried through, but this artist's impression was drawn up to show what it may have looked like. (*Bob Peacock Collection*)

8 JANUARY 1991

Building work got underway on new residential properties at the junction of Ledsam Street and Great Tindal Street, on a site once occupied by Hereford House and Ploughfield House; 60 flats and 23 houses were eventually built.

9 JANUARY 1967

The Turf pub at the junction of Monument Road and Spring Hill closed to make way for the improved traffic junction. Dancegoers heading for the nearby Palais de Danse on Monument Road frequented the pub in pre-war days.

10 JANUARY 1954

Christian Kunzle, the well-known chocolate and cake manufacturer, who had a large factory at Five Ways, died on this day. He built up one of the leading confectionery and catering firms. Kunzle looked after his employees and took many of them and their children, who were suffering from bronchial diseases, to his home in Switzerland so that they could experience fresh air, recuperate and have a gateau in a chateau.

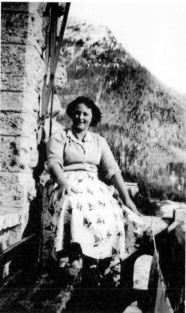

One of the workers at Davos.
(Alicia Foxall Collection)

11 JANUARY 1979

According to the Ladywood School logbook, 'A party of six children visited the BBC Pebble Mill to take part in the TV programme *Pebble Mill at One.*'

12 JANUARY 1884

A boiler explosion occurred at the works of Thomas Bolton & Sons on Broad Street. Fireman Charles Elkington was scalded to death. The disaster was caused by operating an 'almost worn-out boiler flue at a steam pressure much greater than was suitable or safe for it.'

13 JANUARY 2010

Severe snow, by modern standards, caused chaos across the city, schools were closed and photographers went out and enjoyed themselves! However, the winter of 1963 was much more severe as the Edgbaston Observatory, at Perrott's Folly on Waterworks Road, noted it was the 'coolest winter since records began 75 years ago.'

Oratory RC School, Oliver Road.

A snowman in the sun on Ledsam Street with the former Belliss & Morcom building in the background.

14 JANUARY 1961

The much-loved Crown Cinema on Icknield Port Road closed on 14 January 1961. The last film was called *The Angry Red Planet*. The building eventually became the Bill Landon & Sons bathroom centre and it is pictured (opposite, top) during demolition as the last wall was about to be knocked down. The aerial view (opposite, bottom) dates from the late 1960s.

15 JANUARY 1891

The local papers reported the hair-raising news that, 'The hairdressers of the Ladywood district have resolved to close their several establishments on every Thursday afternoon at two o'clock for the rest of the day. It is hoped that the other hairdressers in the city will follow the example of the Ladywood district, so that the half-holiday may be made general through the city.'

16 JANUARY 1883

King Edward VI Grammar School opened at Five Ways where it stayed until moving to Bartley Green in 1958. In 1983 the Lord Mayor, Cllr Peter Hollingworth, unveiled a small plaque to commemorate the centenary of the opening of the school, and this can be seen on the site of the now-demolished building, in the middle of the island at Five Ways.

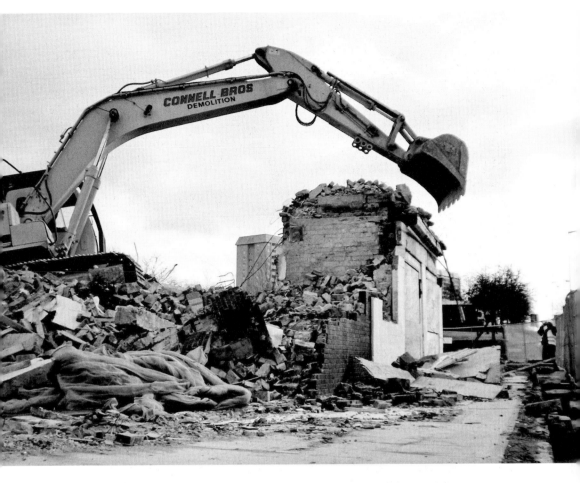

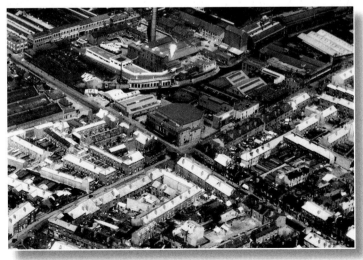

17 JANUARY 1877

The local press described John Henry Newman's home at the Oratory as 'an ugly red brick building, shaped in the most modern of modern styles, in a suburb full of other ugly red brick buildings, with a narrow strip of ground before it planted with dingy shrubs, standing back a little from the street as if overshadowed by the grandeur of the neighbouring bank and inn.' Today the building still stands and is seen below decked out for the visit of Pope Benedict XVI in September 2010.

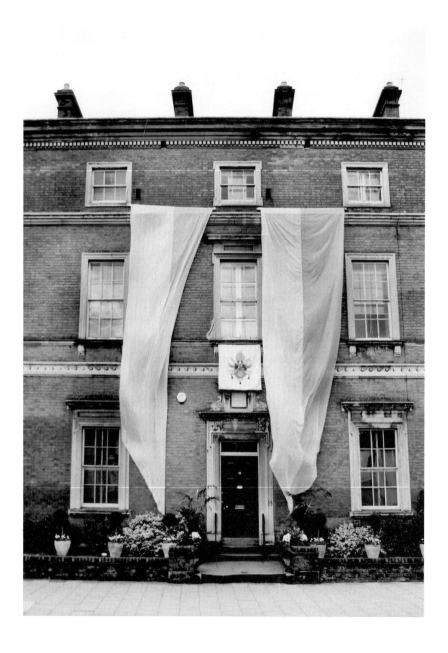

18 JANUARY 1956

According to the St George's School logbook, 'numbers are now 278. An increase on last term but well below last year. A few children have been admitted from new flats in Ladywood Road, but it will be some time before the losses due to demolition are made good.'

19 JANUARY 1880

Pastor Francis Robinson of Oliver Road wrote to the *Birmingham Daily Post* about poor children. He wrote, 'During the last six weeks the leaders of the Ladywood Chapel have been gratuitously supplying, twice a week, to poor children of the district, strong soup dinners. More than 800 dinners have thus been provided. We have done what we could, and in order to continue the sorely needed supply of food, we earnestly ask for public support.'

20 JANUARY 1926

The BBC studio opened on Broad Street. It was, at the time, the largest broadcasting studio in the world. In later years it became known as the centre from where the long-running radio serial *The Archers* was based.

21 JANUARY 1927

According to the St Peter's School logbook, 'The weather, this week, has been most severe. There have been heavy falls of snow followed either by hard frosts or a quick thaw. Many children have slight colds and have looked very poorly.'

22 JANUARY 1991

A ceremony was held on Bath Row at the ruined St Thomas' Church to inaugurate the colonnades which were earlier removed from near the Hall of Memory on Broad Street. The newly designed gardens formed a Peace Garden that opened on 2 December 1992.

23 JANUARY 1869

A tragedy occurred during a birthday party at the house of George Hughes, a glassmaker of Stour Street. While going upstairs, partygoer Eliza Kirkham's head came into contact with a paraffin lamp, which was hanging from a ceiling. The lamp fell and set her clothes alight. She was seriously injured 'on the neck, back and extremities' and was rushed to the General Hospital 'where every attention was paid to her, but she gradually sank, and died.' An inquest jury returned a verdict of accidental death.

24 JANUARY 1898

This day marked the death of George Dixon, a former Birmingham mayor and Member of Parliament who fought for free education for all. His funeral service was held at St Augustine's Church, Edgbaston, and thousands of people lined the route from the church to his burial place at Witton Cemetery. His name lives on in the school on City Road.

25 JANUARY 1901

According to the Immanuel Boys' Church of England School logbook, 'To enable the boys to witness the Proclamation of King Edward VII the registers were closed as soon as possible after 9.00 and the boys left school shortly after eleven.'

26 JANUARY 1968

According to the St Peter's Infant School logbook, '[a] P.E. adviser visited to see if he could help by giving us an allocation of large apparatus. When he saw the lack of space he decided it would be a waste to even contemplate it. Head teacher agreed.'

27 JANUARY 1928

The amateur and professional dancing championships of the Midlands were held at the Palais de Danse. The amateur winners were Mr Deighton and Miss Whitworth and the professional winners were Mrs Webster Grinlong and Mr Jack Downing.

28 JANUARY 1936

According to the Nelson Street School logbook, 'School was closed today on the occasion of the funeral of the late King George V.' The entry in the City Road School logbook refers to him as 'our beloved late King George V.'

29 JANUARY 1891

Arthur Randall, aged eighteen, a farm labourer of Warstone Lane, was charged with stealing four oranges and four coconuts from a fruiterer in Crabtree Road. He was sent to prison for six weeks with hard labour.

30 JANUARY 1965

On the day of Winston Churchill's funeral, the *Evening Mail & Despatch* featured a group of Ladywood housewives who had painted a 'STOP' sign on the road at the junction of King Edward's Road and Garbett Street because they said the road was too dangerous. The picture shows John Reynolds, Ann Whitlock and Pat Ingram. 'We decided to do something before one of the children is killed,' said Mrs Ingram.

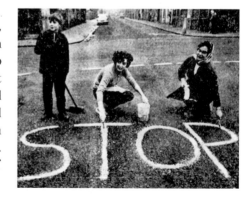

31 JANUARY 1962

108 couples won the right to have their own homes on a new estate at Rednal, in a lucky dip ballot held at the Town Hall, organised by the city's Housing Department. The first couple to have their name drawn from the tombola was Frank and Pauline Robinson of Stoke Street.

FEBRUARY

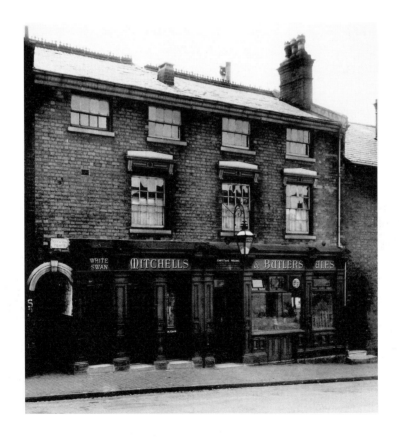

'Last orders!' were called at the White Swan pub on Ingleby Street on 13 February 1966.

1 FEBRUARY 1901

The death of Queen Victoria shocked the nation. The entry in the logbook of St Barnabas' School reads, 'The Board Schools and all the other church schools were closed on Friday owing to the funeral of her Late Majesty, Queen Victoria taking place on Saturday.' The logbook at Steward Street School adds, 'A cross of laurel leaves and flowers subscribed for by the children and teachers will today be sent to the Queen's Statue,' and the City Road Infants' School logbook simply records, 'Funeral of Queen Victoria. Beloved because good and great.'

2 FEBRUARY 1967

Demolition was under way in the Coplow Street area. Plans for redevelopment of more than 500 unfit homes in a large area of Summerfield were announced: of 1,007 houses in the area more than half were said to be of 'very poor quality'.

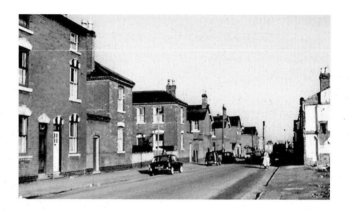

3 FEBRUARY 1962

There was no doubt some amusement in the staff room at City Road School, as the logbook records, 'A medical examination was cancelled as Dr Camell is ill.'

4 FEBRUARY 1916

Extract from St Peter's School logbook:

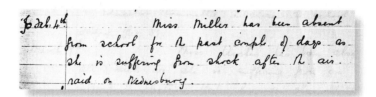

35 people, including the Lady Mayoress of Walsall, were killed when nine Zeppelins penetrated inland, missed Birmingham, and dropped bombs across parts of the Black Country. Walsall's war memorial is located at the spot where she died.

5 FEBRUARY 1989

The Hyatt Hotel bridge link was put in across Broad Street joining the hotel to the International Convention Centre. There was controversy when it was believed the bridge was too short, a problem created when the original shape of the hotel was changed, apparently after the bridge was designed.

6 FEBRUARY 1957

An education department report about St Peter's School noted, 'The school stands in a very crowded part of Birmingham and inadequate accommodation is to be discontinued under the development plan.' In spite of this the school had a good sporting reputation. This is the 1950 swimming team complete with trophies and shields. Back row: George Rogers, Harold Black, Peter Haywood, David Rogers, -?-. Front row: -?-, Pat McMahon, Henry McKenzie, John Field, Danny Barber, -?-.

(John Field Collection)

7 FEBRUARY 1958

The Icknield Square-based Lesbrook & Co. held their annual dinner and dance with top-name guest acts the Hedley Ward Trio and comedian Arthur Haynes. Dickie Henderson was the previous year's guest and opportunity knocked for Hughie Green after he too hosted one the events.

8 FEBRUARY 1928

The complete Inner Circle motor omnibus route opened on this day. It was originally set up in sections with the route through Saltley being the first to open. It served many of the area's biggest employers such as Bulpitt & Sons, and further afield the route was always packed with workers from Ansells brewery, Lucas, BSA and HP Sauce. The photograph below shows two number 8 Inner Circle buses outside the Mint on Icknield Street in May 1956.

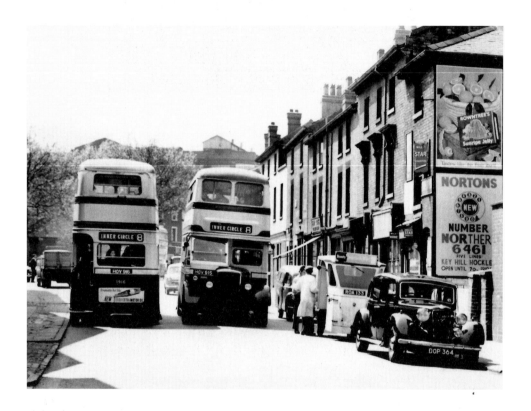

9 FEBRUARY 1967

Cilla Black was interviewed by the *Planet* newspaper at Five Ways while filming for *Work is a Four-Letter Word.* Apparently, 'Crowds hardly recognised her in a crumpled dark blue headscarf, three-quarter length turquoise mac, plain brown skirt and black flat-heeled shoes.'

10 FEBRUARY 1981

The logbook of Ladywood School records the end of an era: 'Demolition of annexe complete.' This was the original Follett Osler premises that dated from 1875. It can be seen in on the left of the undated photograph (opposite, top) when the school was still functioning at the heart of a heavily populated residential area.

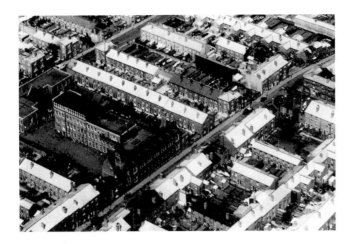

11 FEBRUARY 1976

Figure skater John Curry, who was trained at Summerhill Ice Rink, won Britain's first Olympic gold medal in the sport in front of 10,000 people in Innsbruck. *The Times* called it 'masterly in its cool beauty of movement.'

12 FEBRUARY 1987

Ladywood School was one of only four schools in the Midlands to receive the 'Recognition for Achievement in Education/Industry Collaboration Award'. It recognised the school's achievements in forging links with local industry creating work experience for pupils.

13 FEBRUARY 1990

The Sports Council handed over a cheque for £3million to the city council as its contribution to the building of the National Indoor Arena. Athlete Phil Brown, -?-, Olympic swimmer Nick Gillingham and judo star Elvis Gordon hold up the cheque watched by Cllr Pat Sever of the ICC Committee, wife of former Ladywood MP John Sever.

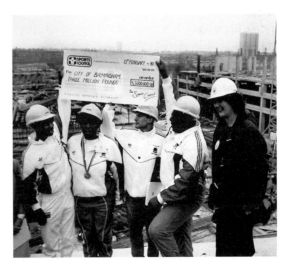

14 FEBRUARY 1964

Six children were rescued from a fire at 118 St Mark's Street after a cellar filled with smoke from a burning mattress. Pictured are the rescued children of George Whitson: Tina, Derek, Tony, Marie, Elaine and George.

15 FEBRUARY 1909

The death of G.E. Belliss, aged seventy, was reported in the press. 'Commencing in a relatively small way of business, he rapidly built it up until it stands today, one of the foremost engineering concerns in the country.' He began by working at Richard Bache engineers on Broad Street before linking up with Alfred Morcom and establishing the factory in Ledsam Street where 'it grew to great dimensions'. As these photographs show, Belliss & Morcom became a major employer of people in Ladywood and beyond.

16 FEBRUARY 1883

Sax Rohmer, author of the Fu Manchu novels, was born Arthur Henry Sarsfield Wood at 28 Rann Street. He left Ladywood when he was three years old to live in London. He wrote the first of fifteen Fu Manchu novels in 1913.

17 FEBRUARY 1967

Pupils from local schools attended a tree-planting ceremony at the Civic Centre. The Duke of Marlborough sent a tree from Blenheim Palace, Sir Winston Churchill's family home. The ceremony was organised by the Tree Lovers' League.

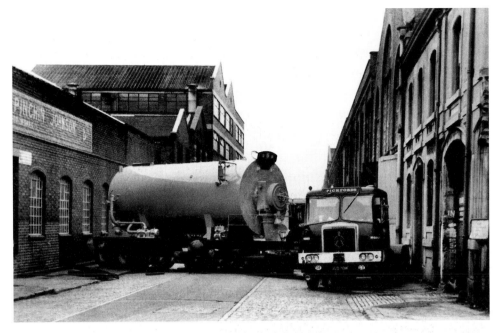

Installation of a new boiler to replace the coal-fired one used for heating the building and power generation at Belliss & Morcom in Rotton Park Street. *(Phil Waldron Collection)*

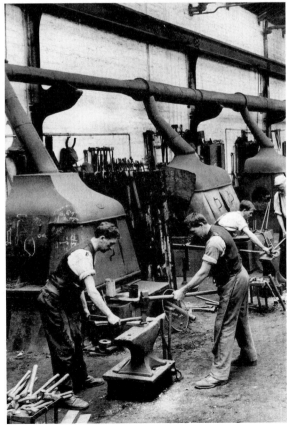

The Belliss & Morcom smithy on Icknield Square, 1923.

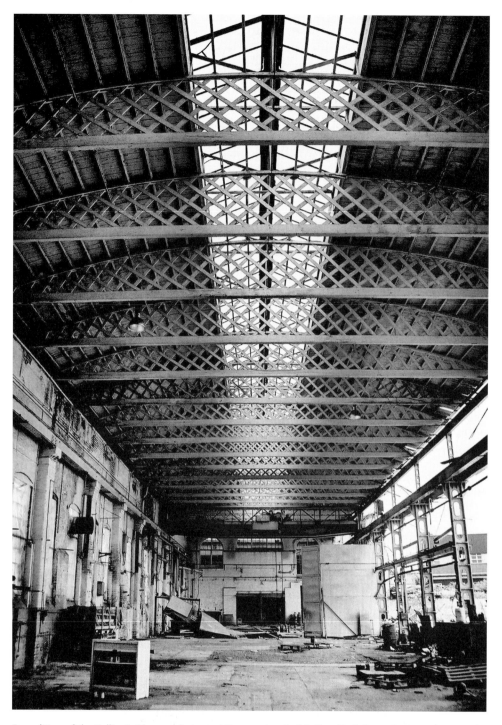

Demolition of the Belliss & Morcom factory at the canal end of Rotton Park Street in 2005 showing the Belfast-style roof structure.

18 FEBRUARY 1955

There was some good news for pupils at Barford Infants' School that had the headteacher wringing her hands with joy. The logbook records, 'A row of washbasins each with hot and cold water has been installed in the cloakroom.'

19 FEBRUARY 1952

Sir Peter Bennett, MP for Edgbaston and Parliamentary Secratary at the Ministry of Labour, opened the Business Efficiency Exhibition in Bingley Hall.

20 FEBRUARY 1965

The *Birmingham Evening Mail* announced, 'Twin tower blocks of municipal flats, 330ft high and called the Sentinels, are proposed in a £3m scheme at Holloway Head.' The blocks were named Clydesdale Tower and Cleveland Tower, after breeds of horses, the blocks having been built in the 'neigh'-bourhood of the Horsefair.

21 FEBRUARY 1801

John Henry Newman was born in London on this day. He became a prominent priest at the Oratory after converting to Catholicism and was Beatified by the Pope in September 2010.

22 FEBRUARY 1878

Haynes's flourmill on Icknield Port Road, between Osler Street and the canal, was destroyed by fire. It aroused a great deal of interest in the city because it is believed that this was the first time the fire brigade had been able to use their new steam engine. The *Birmingham Daily Mail* reported, 'The entire stock, consisting of flour and wheat, to the value of several thousand pounds was destroyed. The steam engine played with capital effect, and had the engine been in attendance at an earlier period of the conflagration, very considerable damage would have undoubtedly been averted.'

23 FEBRUARY 1998

According to the Oratory School logbook, 'A member of Edward's Trust, a charity which provides temporary accommodation for parents with children who are receiving treatment at the Children's Hospital, came and talked about their work. This charity has been chosen to fundraise for during Lent.'

24 FEBRUARY 1961

An entry in the logbook of St George's Primary School reads: 'Took four children to Town Hall to receive National Certificate for Prevention of Accidents.'

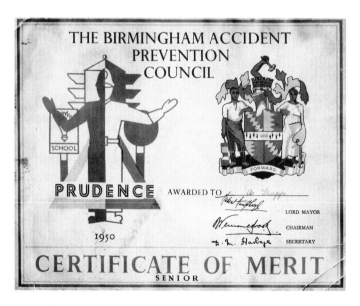

Every school in the city took part in road safety initiatives. Barford Road School pupil Albert Trapp won this certificate in 1950.

25 FEBRUARY 1937

According to the Nelson Street School logbook, 'There has been much rain during this week. This morning a boot inspection took place. There were an abnormal number of children whose boots, even stockings, were soaked. In some cases nothing had been done to the same to dry them from the previous day. A short talk was given to the children on the dangers attending this indifference.'

26 FEBRUARY 1892

A correspondent in the *Birmingham Daily Post*, A. Matson of Edgbaston, wrote with information on how to obtain good domestic servants as, apparently, the supply had decreased owing to the greater numbers taking up education. He or she asked for more technical schools to teach 'domestic duties'.

27 FEBRUARY 1883

This day marked the opening of Monument Road baths which was used as much for washing as for swimming. Water for the baths was obtained from a well sunk to a depth of 120ft with a diameter of 7ft 6in. From the bottom of the well numerous boreholes were sunk to a depth of 330ft allowing an inflow of 8,500 gallons of water per hour. This was reduced to 5,000 gallons after other wells were dug in the district. The original tank contained 40,000 gallons of water. The Lord Mayor said he hoped people would come to see that it was, 'quite as necessary to bathe in cold as in warm weather.'

28 FEBRUARY 1967

According to the St George's School logbook, 'Classes went to London – a special rail excursion to inaugurate electrification of line between London and New Street – a very enjoyable and interesting day.' On 1 March a similar trip to Liverpool was cancelled 'because of accident previous day.' Also on 28 February, nine people were killed and eleven hurt when a diesel loco and the Manchester to Coventry Express collided near Stechford.

Here and overleaf: adverts from the February 1898 issue of St John's Church magazine.

☞ *Agent for Pickford's Parcel Delivery.* *Parcels sent to all parts of the United Kingdom.*

T. JOHNSON,

THE NOTED

Boot and Shoe Manufacturer,

291a, Monument Rd.,

(Opposite St. John's Church).

MARCH

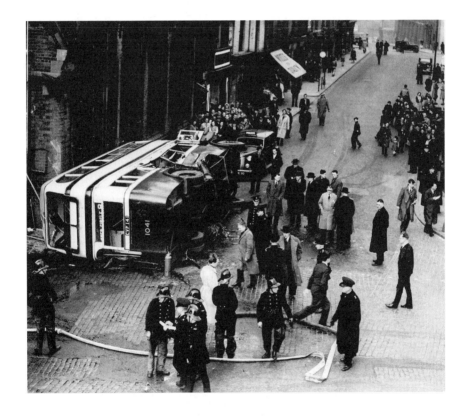

The Spring Hill bus crash, 16 March 1949.
(www.digital-ladywood.org Collection)

1 MARCH 1900

There was much joy at the latest news from the Boer War, the logbook of Immanuel Boys' Church of England School in Tennant Street recording, 'Holiday to celebrate Relief of Ladysmith.' The logbook at St Mark's Street School adds, 'Boys cheered and paraded the streets. Great excitement.'

2 MARCH 1922

Sculptor Raymond Mason was born on this day. He attended St Thomas' School in Lee Bank and made a name for himself as a sculptor of fine statues including the controversial 'Forward' sculpture in Centenary Square. It was unveiled on the day the International Convention Centre was opened by Her Majesty the Queen in June 1991, but was burned down by vandals in April 2004 and not replaced.

3 MARCH 1939

King George and Queen Elizabeth visited Birmingham and spent seven hours touring the city during which time she named the new hospital after herself. School children were given the day off to join in the celebrations. The logbook of St Peter's School notes, 'Apart from the organised stand in Broad Street, the children appear to have spent the day racing from part to part of the city. The result, yesterday was apparent in the laziness of the children.'

4 MARCH 1948

According to the Barford Infants' School logbook, 'Fred S— was taken home by Miss Phelps as he had put a piece of chalk up his nose and could not get it down. His mother took him to the doctor who removed the chalk, and he returned to school.'

5 MARCH 1914

Bill head from Thomas Chatwin Ltd of Great Tindal Street, 5 March 1914. This was a bill sent to a company in Leeds for the supply of 'gas plug taps'. The patriotic Chatwin's business was established in 1849 and named the Victoria Works. Medals illustrated on the billhead represent locations where medals had been won in competitions.

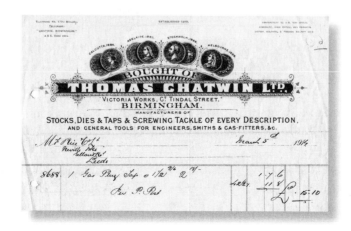

6 MARCH 1823

Birth of Jesse Ascough, 1823–97, who became a leading manufacturer of borax, which is now used in detergents, water softeners, soap and disinfectants. The Borax Company was established in 1876. He advertised in over 3,000 newspapers across Europe and in 1893 he set up a factory in Ledsam Street with space for a canteen and recreational facilities for the workers, who each received free medicals.

7 MARCH 1958

According to the St Peter's Infants' School logbbok, 'A Gramophone and speaker [were] delivered to school. This equipment is in excess of capitation allowance.'

8 MARCH 1927

According to the Nelson Street Boys' School logbook, 'A party of 20 boys paid a visit to Messrs Gillott's pen factory.'

9 MARCH 2008

Calthorpe House, a 170ft tall, 17-storey 1960s office block, was razed to the ground in a controlled explosion at the Edgbaston Shopping Centre at Five Ways. Around 90kg of explosives were used, creating about 10,000 tonnes of rubble. A new retail development called Edgbaston Galleries will replace it (see photographs overleaf).

10 MARCH 1958

According to the St George's Primary School logbook, 'Due to fall in numbers we should lose at least one teacher at midsummer. Demolition in Ladywood continues and some houses in Plough & Harrow Road and Beaufort Road are also unoccupied and boarded up.'

Facsimile of packet.

BORAX Dry Soap.

Pure, antiseptic soap in fine powder. Washes clothes without bar soap, without rubbing them, and without injuring them. Sold in $\frac{1}{4}$ lb., $\frac{1}{2}$ lb., and 1 lb. packets by grocers, oilmen, and stores. The genuine can be identified by packet above. Write for booklet.

The Patent Borax Co., Ltd., Birmingham.

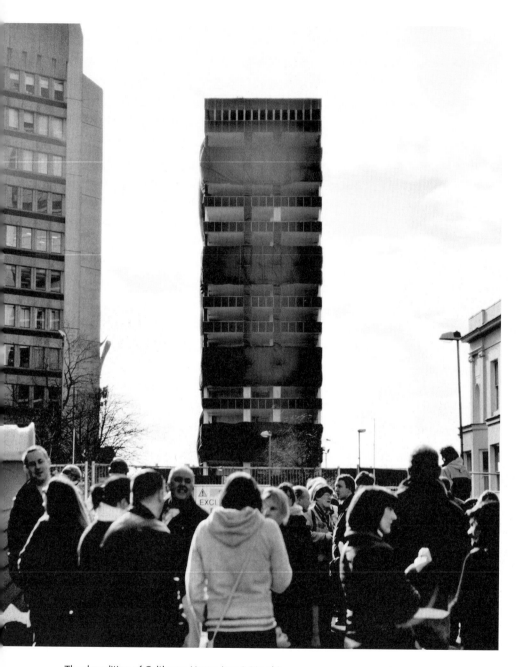

The demolition of Calthorpe House (see 9 March).

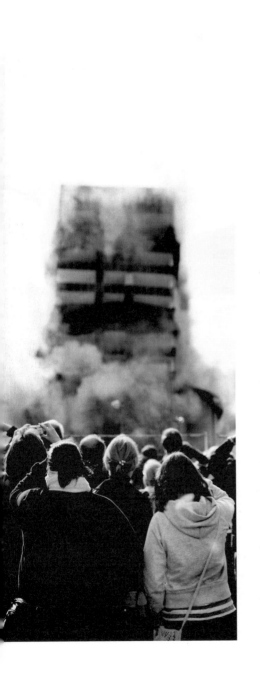
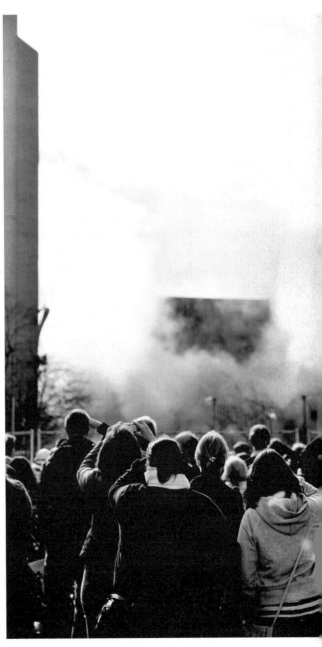

11 MARCH 1907

According to the St Mark's School logbook, 'The Revd who has been vicar at St Mark's for twenty years left today for his new living in Wiltshire. And sad to relate the churchwarden . . . a strong friend, died suddenly about three hours after the old vicar left the parish. He died in his office of heart failure. We are stunned at the calamity that has fallen on St Mark's. Everybody here is staggered and we feel that a pillar of the place has fallen.'

12 MARCH 1930

'The Great Carmo Circus Menagerie & Horse Show' opened on spare ground at the Parade, Spring Hill. It was housed in a huge tent accommodating 4,000 people sitting and 1,000 standing. Two days later, under the weight of more than 100 tons of snow, the great marquee collapsed; luckily, no one was injured. The Lord Mayor attended when the circus reopened five days later. However, on 21 March the circus was again hit by disaster when it was destroyed by fire. Togare, the lion tamer used raw eggs and olive oil to sooth the burns on the skin of the lions. One eyewitness, Ernie Bennett, speaking in April 2002 to the Ladywood History Group's magazine, the *Brew 'Us Bugle*, recalled, 'Everyone was running around with buckets of water and battling the flames with mops and their feet. The hot air was sending up huge pieces of flaming canvas, which drifted across backyards of nearby houses, and we had to stamp out the flames with our feet. We could hear the distressed animals roaring and it definitely caused quite a commotion!'

13 MARCH 1888

According to the Icknield Street School logbook, there was the 'Distribution of prizes in connection with examination in "Kindness to Animals". 50 prizes obtained by this school including the Darwin medal in recognition of the fact that this was the third successive examination in which the Champion Prize had been gained by this school.'

14 MARCH 1941

According to the Nelson Street Boys' School logbook, 'Attendance during the week has dropped slightly owing to the fact that the nights have been disturbed by lengthy air raids.'

15 MARCH 1926

According to the Steward Street School logbook, 'The school football team, up to this day holds an unbeaten record in the Western Division League, Villa Cup and HMS Birmingham Shield. I have received a letter from West Bromwich Albion inviting the team to witness a match v Liverpool on 27 March.' (If you are an Albion fan don't bother to the look for the result.)

16 MARCH 1949

A crash at Spring Hill involving a bus and fire engine left one man dead and at least thirty-five people were taken to hospital. The impact of the crash caused the bus to topple over and hit the library. Scaffolding that was around the library at the time, partly gave way, and one piece smashed through a bus window hitting a man on the head: it was that impact that resulted in his death. The inquest found there was insufficient care on the part of both drivers.

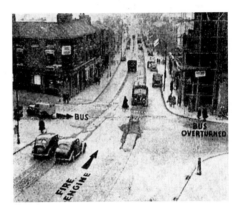

17 MARCH 1978

The sixth Birmingham Motor Show opened at Bingley Hall. It was said to be, 'The most eye-catching and sophisticated yet to be held in the Midlands.' There was a million pounds worth of motor machinery on display and Ryland Street Motors were among many companies to take out adverts in the programme.

18 MARCH 1869

This date marked the birth of Neville Chamberlain who, in 1918, became Conservative Member of Parliament for Ladywood. He rose to become Prime Minister, and at the outbreak of the Second World War, it was he who famously failed to secure 'peace in our time'.

19 MARCH 1891

The St Mark's School logbook says, 'I am sorry to find that Mr — appears totally unable to teach geography or in fact any subject that requires intelligent teaching.'

20 MARCH 1968

Opening of Ladywood fire station by Cllr Alderman Meadows OBE. It replaced the Albion Street premises in the Jewellery Quarter.

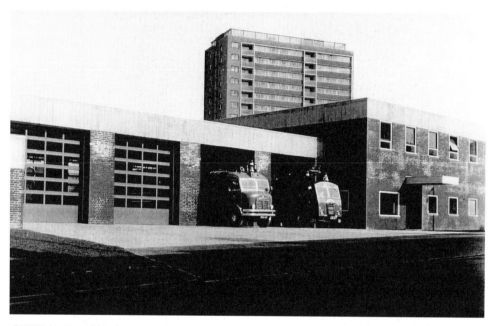

(WMFS Heritage Group)

21 MARCH 1960

The *Birmingham Evening Mail* reported that Henry Wiggin & Co., the nickel alloy manufacturers, are to transfer to Hereford in a move to be 'substantially completed by 1963'.

22 MARCH 1808

Abraham Follett Osler was born on this day. He became a well-known manufacturer of glass chandeliers and cut glass, and was a wealthy local benefactor. He is pictured (opposite, top) with his wife, Mary, on the occasion of their 60th wedding anniversary. He was eighty-four and Mary was eighty-six. She was Mary Clark before her marriage; hence Clark Street is next to Osler Street off Icknield Port Road. Osler's glassworks was on Freeth Street, and the nearby pub, on the corner of Clark Street was known as the Glassblower's Arms. Pictured (opposite, bottom) are George Garrett, Maureen Hale, Pat ?, Jimmy ?, Alan Hewings and Eric Martin. *(D. Busk Collection)*

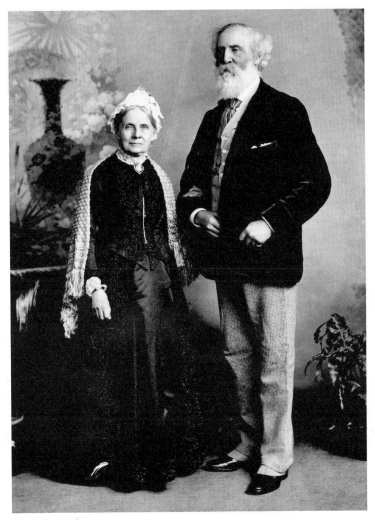

23 MARCH 1887

Queen Victoria visited Birmingham to lay the foundation stone for the Victoria Law Courts on Corporation Street. As part of her visit she spent a significant amount of time at the Town Hall and the Council House. All schools were closed for the occasion.

24 MARCH 1964

Osmag was the magazine of Osler Street Boys' School. This is the cover of the March 1925 issue with a handy map to show those who were not too good at geography how to get to the place of learning! Geographers went further afield in March 1964, a week-long tour was arranged to Belgium under the leadership of Mr C. Jones. A brochure produced for the trip reminded pupils, 'your mother or father will be concerned about you while you are away. You MUST write home frequently.' Also, 'on the crossing go to the lavatory then keep away, you will thus avoid being affected by the people who are seasick,' and, 'in the hotel remember we are guests. Fifty million Englishmen will be judged by your actions.'

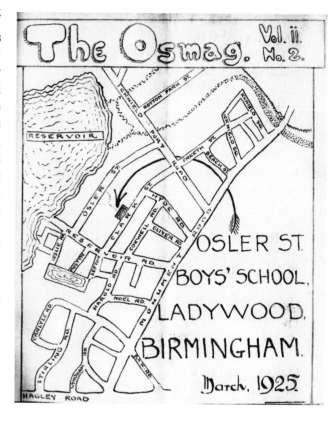

25 MARCH 1992

The *Birmingham Evening Mail* reported, 'up to 135 jobs are to go with the closure of 200-year-old tool manufacturer.' The shock news was broken to workers at Rabone Chesterman's premises between Spring Hill and Camden Street. The news came three years after they were bought by the US group Stanley Tools for $8.5million. The firm was founded in 1784.

(Bernard Fagan)

26 MARCH 1918

This day marked the birth of world-renowned jazz musician Andy Hamilton in Port Maria, Jamaica. Andy came to Britain in 1949 after playing for Errol Flynn on his yacht, and settled in Ladywood where he has lived ever since. He became an ambassador for the Foreign Office, playing at official overseas functions. Now, in his nineties, he still plays regularly at venues across Europe with his band 'Andy Hamilton & the Blue Notes'. He is pictured at the St Mark's Residents' Association 40th anniversary celebrations in May 2010.

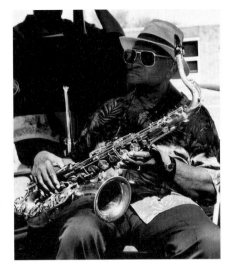

27 MARCH 1905

According to the Steward Street Girls' School logbook, 'Workhouse children residing in Summerfield Crescent are absent this week owing to an epidemic of mumps. They were also absent last week.'

28 MARCH 1890

According to the Nelson Street Boys' School logbook, 'An attempt was made to prevent the boys coming to school. The instigators seemed chiefly boys who had left school and street ruffians. I went out and thumped two or three who began stone throwing and the police came down at the time they went away.'

29 MARCH 1958

Bradshaw's department store, which stretched across both sides of Cregoe Street, closed on this day after fifty-four years of supplying drapery and household goods.

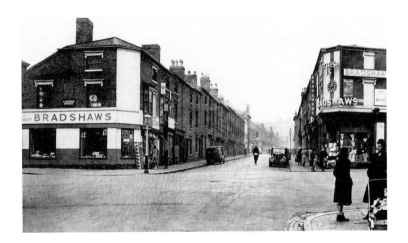

30 MARCH 1955

The Birmingham Co-operative Society Ltd, Greengrocery Department, held a dinner and dance at the Tower Ballroom to celebrate sales of one million pounds for 1954. Entertainment was supplied by the Cliff Deeley Quartet.

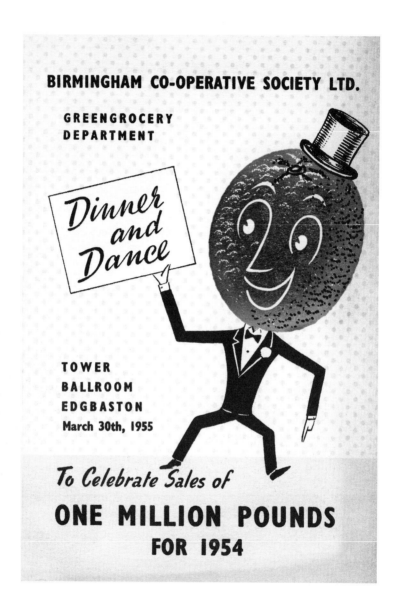

31 MARCH 1840

Laying of the foundation stone took place at St Mark's Church, built at the corner of St Mark's Street and King Edward's Road, which was eventually consecrated in July 1841.

APRIL

Key Hill at Icknield Street, 15 April 1974.

1 APRIL 2009

The official opening took place of the Norman Power Care Centre on Skipton Road by Neil Hunt, the Chief Executive of the Alzheimer's Society. The centre is designed as a home for people with dementia and to provide short-term care and support for older people. It is named after Norman Power who was the vicar of nearby St John's Church from 1952 until 1988.

2 APRIL 1958

King Edward VI Grammar School at Five Ways closed on 2 April 1958 and as these photos show, the area around it changed even if the building didn't. Farmers pass by with their sheep in about 1904, with the school building on the right. The same view a few years later and to com-'bleat' the sequence this was the view in 1964, six years after the school had closed. This now is the centre of the island at Five Ways.

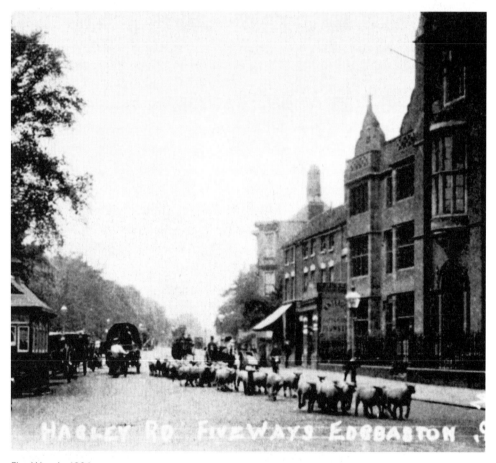

Five Ways in 1904.

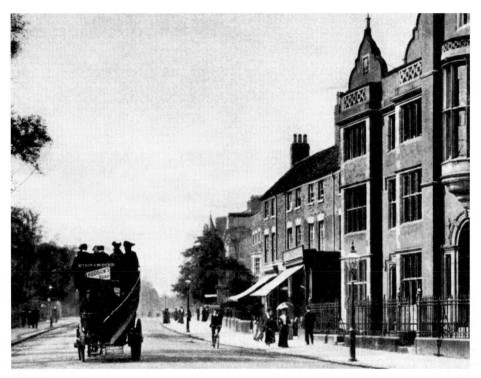

Five Ways, *c.* 1907.

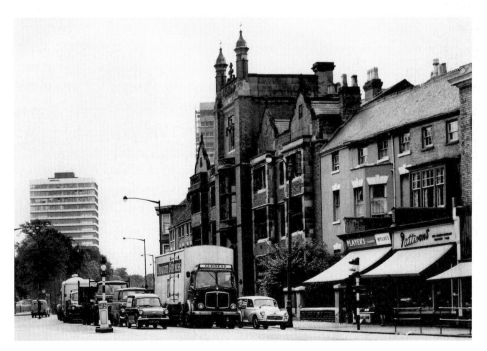

Five Ways, *c.* 1964.

3 APRIL 1893

The local press reported, 'On Saturday a very interesting ceremony was performed in the opening of a drinking fountain in Summerfield Park by the donor, Mrs Sargant, on the site of Summerfield House, pictured, which stood for many years in the centre of the park, but was pulled down in 1889. The house was at one time the residence of the late Mr and Mrs Robert Lucas Chance, and for eighteen years Mrs Sargant, their daughter, lived there. The ceremony concluded with a rush of the children to take their first drink from the new fountain.'

4 APRIL 1937

The Nelson Street School logbook notes, 'School closed for polling in connection with the by-election in West Birmingham consequent upon the death of Sir Austen Chamberlain.' He was the eldest son of Joseph Chamberlain and was brought up as a Unitarian through the Church of the Messiah on Broad Street. He was Conservative MP for the area from 1914 until his death. The West Birmingham seat was abolished in 1950.

THE BIRMINGHAM GRAPHIC.

5 APRIL 1883

A hoard of dynamite was discovered in a shop on Ledsam Street which was to have been used by terrorists in connection with 'the Irish question'. There was enough explosive material to kill hundreds of people and the find made national news. The sketch shows police constables outside the shop.

6 APRIL 1943

According to the Barford Road Infants' School logbook, 'Bars of chocolate sent from the Optimists (Canada & United States) via Lord Mayor for the children.'

7 APRIL 1970

Eight pupils and two teachers from George Dixon School left for a trip to visit the area around Barcelona returning on 21 April. Teachers were Messrs MacKinnon and Eley. The pupils were Henry Barrell, Geoff Tedstone, Ray Bridgwater, Karl Mills, Bob Scott, Richard Hinton, Max Francis and Gary Cowdrill.

8 APRIL 1932

The Lord Mayor, Alderman Sir John Burman, opened the Crescent Theatre. The first play was *The Romantics* by Edmond Rostand. The theatre was named after the crescent-shaped block in which it was based near Cambridge Street. They moved to Cumberland Street in 1964 and are now based in Sheepcote Street.

9 APRIL 1941

A night of heavy bombing raids over Birmingham saw the Prince of Wales Theatre on Broad Street destroyed. This is from the logbook of St Peter's School, the nearest school to the incident:

25th April. The children returned to school last Monday after the holidays. On the nights of the 9th & 10th, there were again very severe air raids on Birmingham. Some bombs fell very near both school. Some of the Prince of Wales

429

Theatre others demolishing buildings on the opposite side of Broad Street. A huge brick was flung through the school roof & fell into one of the class rooms.

10 APRIL 1893

On this date the letter below was sent to the local press:

Sir,

I should like to call attention, through your column, to the lawlessness of the neighbourhood surrounding Monument Lane station. Down several of the adjacent streets, pedestrians go with great risk to sense and limb, and Icknield Square seems quite at risk of the rowdy element. Cannot something be done to end this state of things, and enforce the law, which exists to put down such dangerous games as tipcat in the streets?

Signed by 'Order'.

11 APRIL 2003

The *Birmingham Evening Mail* featured the closure of the Docker Bros paint factory in Rotton Park Street after 120 years of production. At the time of its closure the firm had been absorbed in to the PPG paints empire. In its heyday, Dockers employed over 500 workers and produced 25 million litres of paint per year for railway carriages, cars, tanks, planes and motor racing cars.

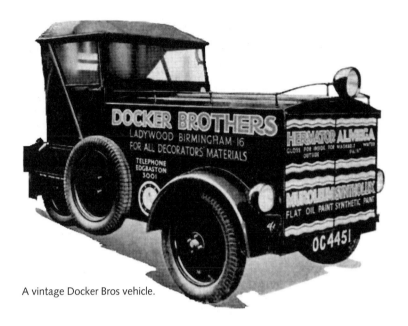
A vintage Docker Bros vehicle.

12 APRIL 1962

An orchestral concert was held at George Dixon School 'as an expression of thanks to the parents for their generosity during the past year in giving the school two flutes, two oboes, a viola and a double bass.' It was planned to 'show the abilities of our players and to foster them by providing the valuable experience of performing in public.' So said the school magazine, *Dixonian.*

13 APRIL 1973

According to the Ladywood School logbook, 'Last day of term. Sixty-four children, mainly of Ugandan Asian origin, visited the school to prepare for admittance next term.'

14 APRIL 1906

Opening of Rosebery Street tram depot. Eventually over seventy trams made tracks there and it converted to bus use before closing in June 1968.

15 APRIL 1887

The press reported, 'The new Board school, Barford Road near to the Icknield Port Road railway station, will be opened on Wednesday next, by the Right Hon. Viscount Cranbrook, Lord President of the Privy Council.'

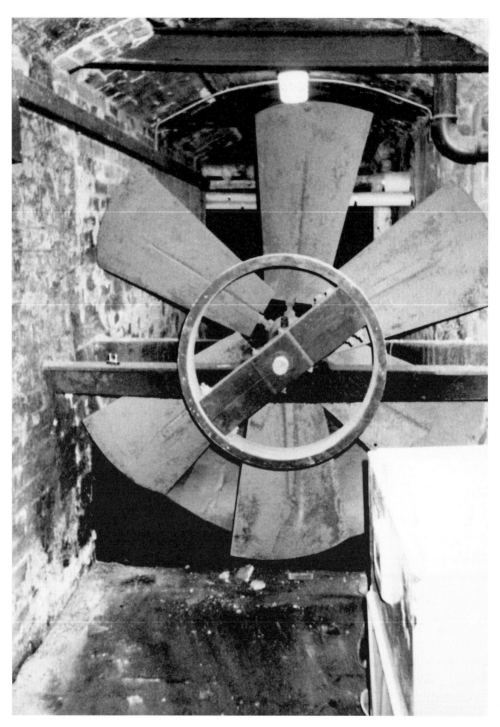

This view of Barford School rarely seen by pupils or teaching staff shows the hot air fan in the chambers beneath the school. *(Barford School Archive)*

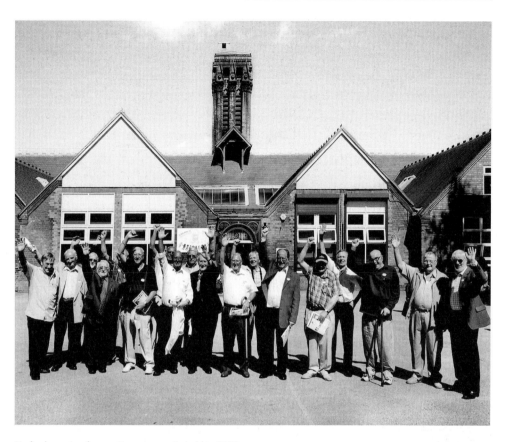

Barford reunion for wartime era pupils held in 2005.

16 APRIL 1952

The death of Frank Archdale, managing director of engineering firm Archdale's of Ledsam Street was announced on this day. His father, James, founded the company with an iron foundry in Icknield Square in 1868 and they later expanded on to Ledsam Street. Eventually they outgrew the site and moved to Blackpole in Worcestershire taking some of the workforce with them.

17 APRIL 1940

According to the St Peter's School logbook, 'Compulsory attendance came into force today. Much time is being devoted to the "three Rs" as it is found that the children have gone back most dreadfully. The junior classes are most terrible.'

18 APRIL 1964

The Birmingham Ice Skating Rink at Summerhill closed. On the final evening it was reported that 800 people were waiting in the queue for it to open and many teenagers were singing and blowing bugles. At the time of closure there were two Olympic and seven

An advertisement for Archdale's drills, July 1955.

international skaters in the Mohawks skating team based at Summerhill. The *Evening Mail & Despatch* stated, 'one of the main attractions of the city's entertainment world was closing its doors today after 34 years.'

19 APRIL 1900

Birth of Victor Francis Yates who became a clerk at Cadbury's, and MP for Ladywood 1945.

20 APRIL 1893

The first issue of books took place at Spring Hill library; it had opened in January that year as a Reading Room.

21 APRIL 1951

A Ladywood no. 95 bus on the last day that Paradise Street was used as a terminus. The 95 bus took over from the 33 tram on 1 September 1947. Today the no. 80 operates a similar route.

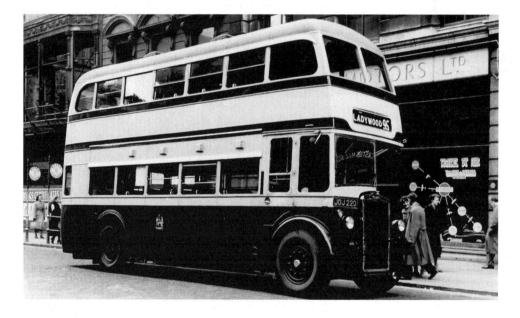

22 APRIL 1904

According to the Steward Street Boys' School logbook, 'Owing to another outbreak of measles at the workhouse, the twelve boys in attendance will be removed from the register today.'

23 APRIL 1913

HRH Princess Louise, Duchess of Argyll, King Edward VII's sister, visited Birmingham and laid the foundation stone at the Children's Hospital, officially known as the King Edward VII

Memorial Hospital. The hospital has since moved to the old General Hospital site and the original building demolished, except for the façade on the Ladywood Road side which has been incorporated into an entertainment complex known as Broadway Plaza.

24 APRIL 1895

A resident of Friston Street wrote to the *Birmingham Daily Post* to compliment the local police. He witnessed a police constable catch a woman who 'for some unknown cause threw herself out of a window, a distance of 26 feet' in Browning Street. The writer of the letter added, 'the police constable, at great personal risk, caught her in his arms, thus saving her from death. I think this brave act ought to be recorded and rewarded.'

25 APRIL 1900

The local press reported 'some excitement was caused last night at Monument Lane station owing to an accident which occurred to a train of empty coaches. Fortunately no one was injured, but the accident was a serious one.' The first coach crashed into a barrier, 'smashing it and fouling up the main line. The front wheels of the coach were wrenched off and the line was twisted.'

26 APRIL 1907

According to the Osler Street Boys' School logbook, 'Yesterday the clock winder entered the school with a ladder during morning assembly and had to be asked to leave again.'

27 APRIL 1965

The unveiling took place at the new Five Ways shopping area of the statue of Field Marshal Sir Claude Auchinleck, 1884–1981. Auchinleck was the chairman of Murrayfield's, the company that developed the centre, but had no connection with the area.

28 APRIL 1967

The photograph opposite (top) shows a 10ft by 4ft display unit that was first installed in a premises in Cheltenham by Bulpitt & Sons Ltd. Two years later it was modified when the illuminated headboard was added. Clearly Bulpitt's were always on the boil when it came to advertising!

29 APRIL 1914

According to the Nelson Street Boys' School logbook, 'The report of the Birmingham Athletic Institute for 1914 reached me today. This the final paragraph. "Nelson Street School continues to hold the field in Gymnastics, retaining the Shield for the greatest number of passes in exercises on the high and parallel bars, and carrying off all the championship individual prizes. The foundation of the success was laid many years ago, but it stands to the credit of the Headmaster Mr McKenzie, and his enthusiastic colleague, Mr Leng, that they have maintained unbroken the fame of their school for this difficult branch of athletics.'

30 APRIL 1948

According to the St Peter's School logbook, 'On Monday April 26 the school was closed for the occasion of the Silver Wedding of the Their Majesties, the King & Queen.'

Watching Dad at work

In the rolling mill at the Mint during the recent open day, Dennis Bartlam's children, Peter, Carol and Aileen are seen below watching their father at work on the four-high rolls. Report and more pictures on pages 4 and 5.

Sixty relatives and their children of mint workers visited the Icknield Street factory. Among them were Peter, Carol and Aileen Bartlam, children of Dennis Bartlam, who were photographed watching their father at work on the four high rolls. From the *Mint* magazine of April 1979.

Scenes from the annual Old Ladywood Reunion Association meeting at the Clarendon Suite which was attended by around 400 people in April 2010.

MAY

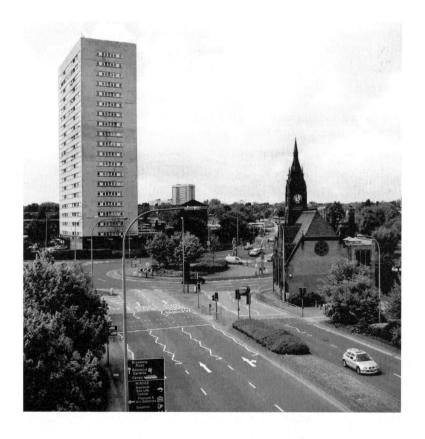

Spring Hill library and Canterbury Tower from the roof of the
former Bulpitt & Sons factory in May 2009.

1 MAY 1950

The logbook of Barford Road School notes that some children were 'having dinners at the British Restaurant in Summerfield Park.' This was a communal centre originally set up during the Second World War providing hot meals to people during the day and helped subsidise rationing and encouraged community spirit.

2 MAY 1957

The Queen Mother visited the Bath Row development area during a six-hour visit to Birmingham. She also 'greeted several thousand patients at Summerfield Hospital.'

3 MAY 1935

There was great excitement for the King's Silver Jubilee celebrations. School children were presented with a special medal, a box of chocolates and schools held parties. The Education Committee granted 4d per head for the catering. For adults there was entertainment in various open-air venues including Chamberlain Gardens where there was a Punch and Judy show, while a band played in Lightwoods Park and the Rothwell Temperance Band performed in Summerfield Park.

4 MAY 1934

According to the St Peter's School logbook, 'The various classes, for summer activities, began last Monday. In each week there will be two classes for girls' swimming and three classes for the boys, all at Monument Road Baths. In a short time, a class will be taken to Cannon Hill open-air baths.'

5 MAY 1933

The logbook of St Peter's School notes, 'I think this is an appropriate day on which to record the successes of our football team. During the present season their record was as follows: Champions of W Brum League, Winners of Sports Argus Cup, Finalists Birmingham Schools Football Cup, Finalists Aston Villa Cup. A tribute must be paid to the work of Mr A. Church who had charge of the team.'

6 MAY 1926

The Nelson Street School logbook records, 'Mr — has applied for a transfer "to a school in the suburbs in consequence of eye trouble resulting from the smoky area and the constant use of electric light in the classroom." I have acceded to his request.'

7 MAY 1867

On this day Private James Cooper rescued comrades in stormy seas off the Andaman Islands in the Bay of Bengal and was subsequently awarded the Victoria Cross. A plaque marking his heroism is located on the inner wall of Warstone Lane Cemetery lodge. He is buried there in common ground.

8 MAY 1937

The local press reported, 'Construction will begin almost immediately' on a training centre for Odeon Theatre Ltd on Broad Street. Due to the upcoming Second World War it was not completed and became known as 'the skeleton of Broad Street' until becoming Bush House in 1958. It was the largest Housing Department building in Europe at the time of its construction. It was demolished in 1990 and stood next where the Novotel is now located.

9 MAY 1902

The Nelson Street School logbook notes that, 'Additional lessons in wire work, brick-laying and paper-folding have been taken this week.'

10 MAY 1945

School logbooks record that all schools were closed on 'May 8 and 9 for celebrations for the termination of fighting in Europe.' This was Davenport's advert when no doubt a few beers were consumed not just at home, but also in the pubs and in the streets.

11 MAY 1992

The Oratory School logbook records, 'All the junior classes took part in the Cancer Research in Birmingham Appeal launch in Centenary Square. Roy Castle, the entertainer, a cancer sufferer himself, launched the appeal along with other celebrities such as Jasper Carrott, Denis Howell and the Lord Mayor.'

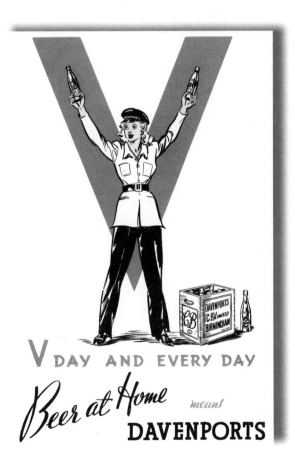

V DAY AND EVERY DAY

Beer at Home means **DAVENPORTS**

12 MAY 1993

Work was underway at the shopping parade on St Vincent Street West. A curved wall was installed and local schools worked with the Ladywood History Group and a community artist to devise slogans to go into it, based on their interviews with local people who had lived in the area for a long time.

13 MAY 1921

According to the St Peter's School logbook, 'On three days during this week, Messrs Ward, pork butchers, sent down about 80lbs of meat to be distributed among the most deserving children.' This was a butcher's shop on Broad Street located near the present-day Lee Longlands site.

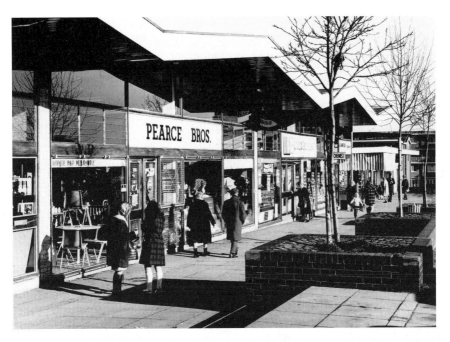

The St Vincent Street shopping parade in 1974. Shops include Pearce Bros which had moved from near the Ledsam Street and Monument Road corner. The lady in the middle of the photograph is entering the Co-op Foodmarket.

The same view in October 2010.

14 MAY 1859

The death occurred of anti-slavery campaigner Joseph Sturge who is remembered with a statue at Five Ways. Around 12,000 people attended his funeral procession.

15 MAY 1891

The *Engineer Magazine* featured a national naval exhibition noting, 'at stand 28 Messrs. Belliss & Morcom have a most interesting exhibit. At the front of the stand is placed a triple air compressor and it is intended for supplying air at high pressure for charging and firing torpedoes; it forms one of a set of three air compressors which are to be supplied to HMS *Royal Oak*. It was launched on 5 November 1896.'

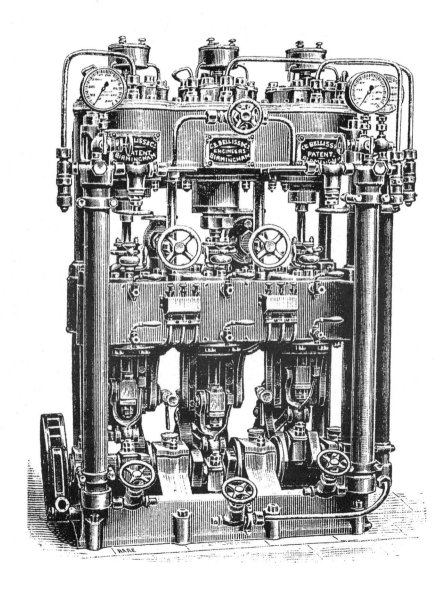

16 MAY 1874

Below is a rare interior view of the altar at St Margaret's Church on Ledsam Street corner. The first stone was laid on 16 May 1874. The cost of this church was about £5,000, and the consecration took place on 2 October 1875.

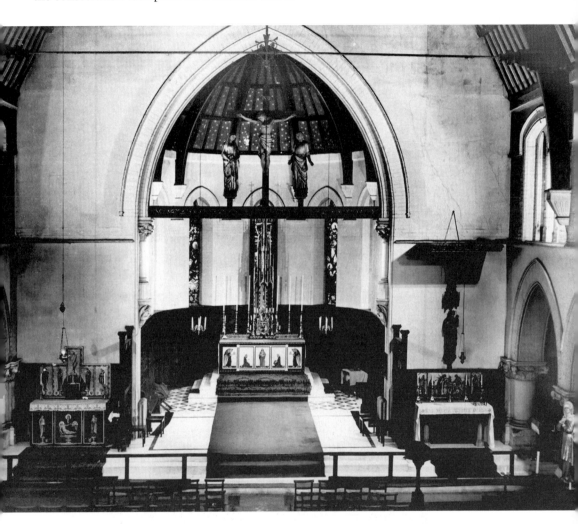

17 MAY 1991

Baroness Fisher of Rednal launched the Ladywood Regeneration Framework, a document compiled by residents and council staff outlining future plans for redevelopment of central Ladywood.

18 MAY 2005

The Ladywood at War exhibition opened at St John's Church, Darnley Road, to commemorate the sixtieth anniversary of VE Day.

Guests at the St John's war exhibition included Montgomery and Churchill look-alikes, and they are alongside Norman Bartlam, who organised the event, Richard Tetlow, the vicar of St John's Church, Eileen Doyle of the award-winning Housing Education Initiative, and the Lord Mayor, Cllr Mike Nangle and Lady Mayoress.

'Churchill' travels along Monument Road heading for St John's Church.

19 MAY 1995

The official opening of phase one of the new Gilby Road estate by Clare Short MP took place. The new homes replaced the maisonettes and blocks of flats such as Elizabeth Fry House, Cavell House and Nightingale House.

Gilby Road estate then and now from St Vincent Street.

20 MAY 1953

According to the St Peter's Infant School logbook, 'The children had their Coronation Party in the school playground. The souvenir Coronation mugs were given to the children and the school closed for Whitsuntide and Coronation Holiday.'

21 MAY 1900

The Immanuel Boys' C of E School Tennant Street logbook records that, 'A holiday was given to celebrate the Relief of Mafeking.'

22 MAY 1987

Teacher Paul Nagle and pupils (below) take a break during Ladywood School's sponsored walk around Edgbaston Reservoir to raise money for the Polio Plus Campaign.

23 MAY 1978

According to the Barford Primary School logbook, 'The caretaker's kitten stuck its head in an electric kettle and had to be taken to the fire station to be released.'

24 MAY 1963

The St George's School logbook notes, 'The Queen's visit to Birmingham. The children lined the route as the Queen and Prince Philip passed down Beaufort Road to view Kenrick House and The Beeches. The school front was suitably decorated.'

25 MAY 2010

A commemoration was held at Oratory School to mark the sixtieth anniversary of D-Day. The family of a former Oratory School head boy and Dunkirk veteran, Herby Carter, unveiled a bench in his honour. In 2004 Herby recorded his memories of D-Day and these were shown to pupils as part of the commemoration which was also featured on *Central Tonight* and tntnews.co.uk.

26 MAY 1873

The First Annual Concert was held in the St Mark's Infant School Room in King Edward's Road. The St Mark's Advanced Singing Class provided the music.

27 MAY 1982

The Oratory School logbook notes that, 'All of the children were presented with a Papal Medal to commemorate the Pope's visit to this country.'

28 MAY 1821

The remains of printer John Baskerville were discovered in his former back garden when the land was dug up to build a canal on the site of the present-day Baskerville House in Centenary Square.

29 MAY 1929

A record from the Nelson Street Boys' School logbook says, 'On complaint of the Girls' School – the Boys' School also suffering – I went to see Bowkett Bros., Clement Street, about a badly smoking chimney, giving out dense and acrid fumes. This has been a frequent source of trouble to the schools, and they promised to get the fires lighted earlier so that the worst of the troubles would be over before school began. As a matter of fact, we get the bother in the afternoon at times, but it would be as well to wait to see what effect this protest has.'

30 MAY 1799

This date marked the birth of John Birt Davies who became the first coroner of the Borough of Birmingham. He held office for thirty-six years and helped establish the Fever Hospital. The Five Ways clock was erected to commemorate his work.

31 MAY 1879

Sarah Alice Vernon, a married woman aged twenty-six, was first stabbed and then flung into the canal at Spring Hill, by her paramour, John Ralph, a hawker of fancy baskets, early in the morning of 31 May. He was hanged for the crime on 26 August.

JUNE

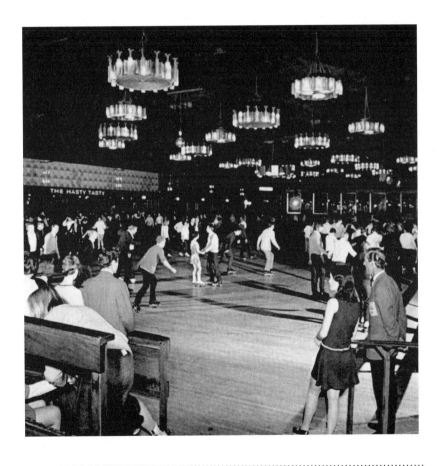

The Summerhill Roller Skating Rink closed on 21 June 1971.

1 JUNE 1953

The first ever Birmingham Safety Rally for cars, motorcycles and autocycles was started outside the Civic Centre on Broad Street. Vehicles travelled along a 37-mile circuit, ending at Castle Bromwich aerodrome. Checkers were stationed at various points along the route observing the conduct of the drivers, and marks were deducted for wrong positioning, bad signals and breaches of the Highway Code.

2 JUNE 1953

On the day of the Coronation of HM Queen Elizabeth II, each child born in the city was given two guineas to open an account at the Birmingham Municipal Bank. In addition 200,000 junior and infant school children received a mug and a tin of chocolates and headteachers in secondary schools could choose gifts for their children from a list which included decorated glass tumblers, propelling pencils and sweets dishes as well as the mug. A canister containing half a pound of tea plus tea caddy spoon was distributed to elderly people. Entertainment included performances by the Great Jaldi & Co. in Summerfield Park followed by the Birmingham Scottish Pipe Band and a fireworks display. There were numerous street parties similar to this one (right) in Alston Street.

3 JUNE 1950

The Midland area of the Stephenson Locomotive Society ran a special excursion train from New Street station to Harborne via Monument Lane creating a welcome return for passenger traffic, even if it was just for one day. The tracks were later dug up but the route of the line can still be traced from the main line junction across the canal where part of the bridge remains near Northbrook Street.

4 JUNE 1862

The statue of Joseph Sturge at Five Ways was unveiled before a crowd of thousands of people. Sturge (1793–1859) was a Quaker who campaigned for peace and was well known as a campaigner against slavery.

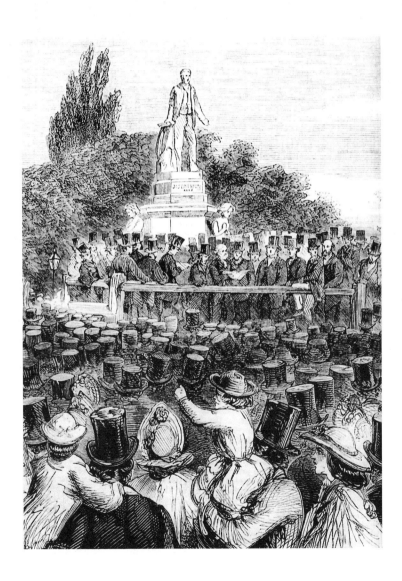

5 JUNE 1989

The Topping Out ceremony was held at the International Convention Centre on Broad Street. Local resident Alice Lynock had the honour of placing a stone on the wall of Symphony Hall. A celebration was then held for a group of 300 people conducted by a town crier whose performance will be remembered by all those who were there.

6 JUNE 1950

Girls from Camden Street School visited London and met Dennis Howell, the MP for their area, All Saints.

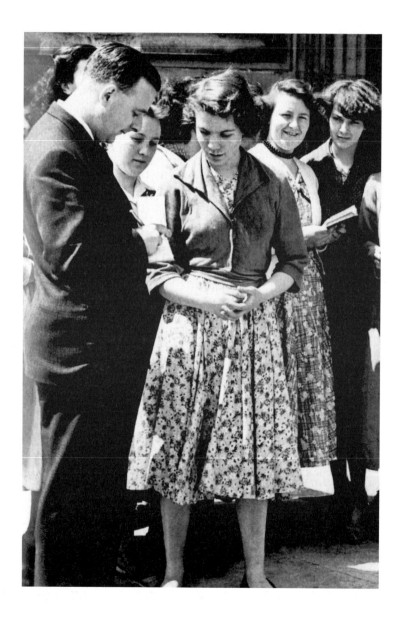

Here is an extract from the sports pages of *Osmag*, the magazine of Osler Street Senior Boys' School, referring to the Annual Sports held on 7 June 1932 and West Birmingham Sports on 24 June 1932.

SPORTS PAGES.

15.

ATHLETICS:

At the Annual Sports – in conjunction with the Girls' School – held on June 7th, the winners were:-

100 Yards, 14 or under, George Swann.
100 Yards, under 13. Harry Shaw.
100 Yards, under 11½. Harold Ridgley.
60 Yards, under 10. George Shutts.
Sack Race, under 10. Charles Harper.
Three-legged Race, under 11½. {Walter Hanson & {Thomas Holbrook
Potato Race, 14 or under. Harold Pursall.
Walking Race, open handicap. Ivor Randell.
220 Yards, open handicap. Fred Oldershaw.
Relay Races:- Senior Boys beat Senior Girls
Junior Girls beat Junior Boys.

Most of these athletes represented the school at the West Birmingham Sports at Cape Hill on June 24th, but though all of them made great efforts, they failed to retain the "Barrow" Shield. Swann, Shutts, Pursall, Pemberton and Crane gained points in heats; Shutts was 3rd. in the 60 Yards final, and the Senior Relay Team was also 3rd. in the final.

Once again, we had the pleasure of congratulating the Girls' School on winning the "Barling" trophy.

8 JUNE 1884

A council report on the funding of Monument Road baths revealed it cost £27,339 6s 8d of which £272 17s 6d was spent on the sewers and £179 15s on paving and kerbing.

9 JUNE 1965

The *Birmingham Evening Mail* reported, 'A bit of Birmingham history will go with demolition of a bomb factory.' This referred to a shop in Ledsam Street in which police discovered dynamite in 1883, stored there in connection with 'the Irish question'. The shop ended life as a tobacconists, run for the last thirty-two years by members of the Wright family.

10 JUNE 1921

According to the St Peter's School logbook, 'There is much poverty among the children at the present time and numerous parents come up daily to apply for tickets for free dinners.'

11 JUNE 1890

A labourer, John Swain, was fined 10s and costs after being spotted by a police constable 'driving a horse at about nine or ten miles per hour down Ladywood Road.' The horse was said to be 'very lame in the left foot.'

12 JUNE 1991

The queen opened the city's International Convention Centre on Broad Street. Pupils from all Ladywood Consortium of Schools were involved; some formed a guard of honour around the new 'Forward' sculpture in Centenary Square and 300 other Ladywood children sang a musical fanfare for the queen as she was shown round the interior of the building by the Lord Mayor, Cllr Bill Turner, who lived in Ladywood.

13 JUNE 1902

The St Mark's School logbook notes, 'I taught a Coronation Song to 3–6. Medals for the Coronation came from the Mint.' This was the Coronation of Edward VII who succeeded to the throne on the death of Queen Victoria in January 1901. The ceremony was scheduled for 26 June but owing to his illness it was delayed until August.

14 JUNE 1968

Official opening of the new St George's School on Beaufort Road by Dr Temple, a former pupil of the school. The school diary records there was 'a very enthusiastic and thrilling gathering' of 250 people.

15 JUNE 1974

Summerhill figure skater, Janet Sawbridge, born in 1947, was awarded the MBE. Between 1963 and 1974 she competed in twelve World Championships and eleven European Championships, with three different partners. She was three times British Ice Dance champion and following her retirement from competition, coached at Solihull.

16 JUNE 1876

The Osler Street Boys' School logbook notes that, 'Two boys (names withdrawn) are confirmed truants. The parent of one, Mr — is blind and deaf, and the mother of the other is partially blind and a widow in poor circumstances.'

17 JUNE 1878

The Dudley Road Board School Boys' Department opened admitting 168 in the morning and 54 more in the afternoon, making a total of 222 on the first day. This school later became Summerfield School and is now a community centre.

18 JUNE 1897

The Osler Street Boys' School logbook records 'Holidays on 21st and 22nd on account of the celebration of the Queen's Diamond Jubilee.'

19 JUNE 1914

According to the Nelson Street Boys' School logbook, 'About 105 boys of all standards left at 2.05 p.m. to see Captain Scott pictures at the Prince of Wales Theatre' on Broad Street.

20 JUNE 1964

It was Carnival Day for students in Birmingham and the brochure for the event included these adverts from local companies. One of the competition prizes was a 'Siren' electric kettle made by Bulpitt & Sons Ltd.

21 JUNE 2005

The Cross Keys pub on Steward Street made the news when the owner put it up for sale by raffling it off with tickets at £25 each. In early July it was revealed that the idea had been scrapped as only around fifty-eight tickets had been sold.

22 JUNE 2006

The *Birmingham Evening Mail* reported, 'Plug is pulled on empire of suds', bringing news that Landon's 'world famous bathroom showroom is to close after nearly 50 years. Their past customers read like a who's who of some of the biggest names in showbiz, sport and music: Ron Atkinson, Jasper Carrott, Steve Bruce, Robert Plant, Fatima Whitbread and Tessa Sanderson were all listed as former customers,' plus 'half the cast of *Crossroads*.' Hopefully the other half washed as well.

23 JUNE 1939

Extract from Religious Examination at St Peter's Infant School: 'it was hard to imagine that they were children of the slums, except from their accent. Their behaviour and deportment were excellent.' The inspector was called Oswald Joyce – presumably he wasn't a local man!

24 JUNE 1924

Neville Chamberlain MP formally opened the Chamberlain Gardens recreation ground at the corner of Ladywood Road and Monument Road. It was 4 acres in size and was given to the city by the Hon. Mrs Anstruther Gough-Calthorpe. Equipment was paid for from private subscriptions and the Fenney Trust.

25 JUNE 1884

According to the Osler Street Boys' School logbook, 'The boy Wolstenholme elder, a most disreputable boy, actually refused to do what he was told, point blank. Punishment was attempted to be inflicted, but the effect was a dreadful howl and kicking, before a stroke could be inflicted. His parents are I am afraid equally bad. I sent for the mother, but could not make her see his error. The case is one for expulsion. He is altogether so much worse, morally, than the other boys that he ought to be expelled.'

26 JUNE 1969

Wallace Lawler, Liberal candidate, won the Ladywood parliamentary seat in a by-election following the death of Victor Yates MP. He lost the seat in 1970 to Doris Fisher, later to become Baroness Fisher of Rednal.

27 JUNE 1940

Cllr F.T. Beddoes opened the new Monument Road swimming baths on this day. Just before the Second World War broke out it was decided to demolish the original Victorian building and replace it on the same site with this new facility. The size was restricted by plans to widen Monument Road.

(Local Studies & History Library)

28 JUNE 1966

A man called John Stokes went into the *Guinness Book of Records* this week after sitting in a barrel on top of pole for 32 days and 14 hours. In so doing he shattered the record of 31 days and became the European Pole Squatting Champion. It was part of a publicity stunt for the ice rink at Summerhill. It was reported that his temporary home had an electric heater, a small stool, a power point for a light, a telephone, a lot of cup hooks on which to hang things, a toothbrush, combs and other personal items.

29 JUNE 1927

On this day there was a total eclipse of the sun. It coincided with St Peter's Day and the church of that name at Spring Hill chose that day to celebrate their centenary, although the church was consecrated in August 1827 in Dale End. The church moved to Spring Hill and the consecration took place in July 1902. The headmaster of Nelson Street Boys' School took 'special leave of absence to visit [the] totality belt of the solar eclipse.' Presumably he told his staff so they were not left in the dark as to the reason for his absence.

30 JUNE 2009

A publicity photocall was held in the former Bulpitt & Sons factory on Icknield Street/ Camden Street to announce the start of a scheme to turn the derelict building into accommodation and offices. Iris Bulpitt presented Norman Bartlam of the Ladywood History Group with a set of Bulpitt's hollowware, made in the factory, to add the group's memorabilia collection.

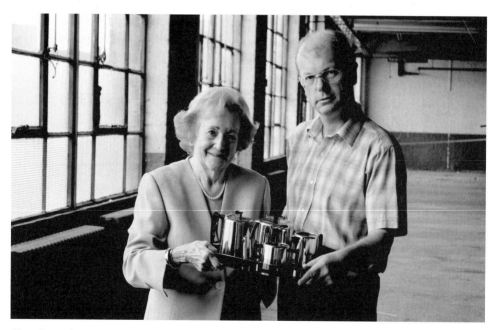

(Kane Romeo)

JULY

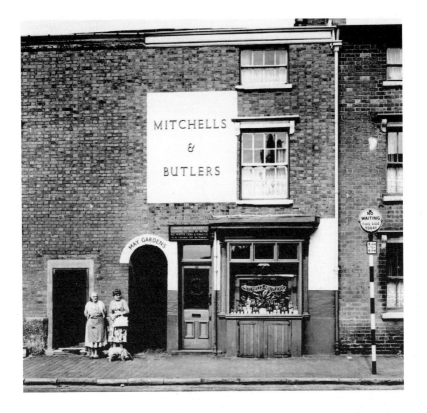

The sign may say 'No Waiting' but the two ladies seem to be waiting for Mary Eccles to open her door on Ruston Street presumably so they can get home to celebrate the moon landing, 21 July 1969.

1 JULY 2005

Barford School officially opened the extension to their building and, after consultation with the Ladywood History Group, named the new rooms in honour of local people. One of the rooms was named after the late Bill Landon of bathroom fame. His wife Rosa attended the event that was declared open by Ladywood MP Clare Short.

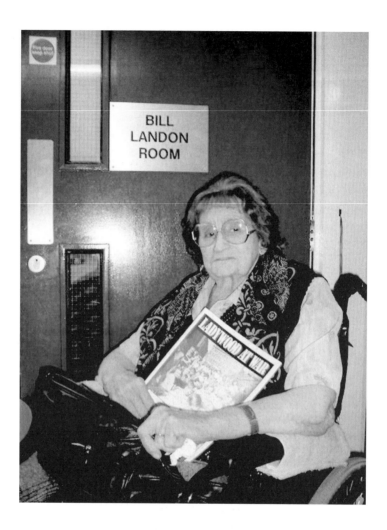

2 JULY 1943

According to the St Peter's School logbook, 'All last week there was little schoolwork done since it was "Wings for Victory Week". There were numerous attractions round the Hall of Memory and these children patronised the place well. Consequently it was after midnight before the children went to bed. Birmingham's target for the week was £12,000,000 – but that target was well passed. In school we collected just over £112.'

3 JULY 1884

The St George's Boys' School logbook noted that, 'Because of the bad state of the walls of the gardens in Beaufort Road, and Plough and Harrow Road, covered with chalk marks, writing etc done by children in these schools, I have put two boys on two afternoons of this week to scrub them.'

4 JULY 1925

HRH Prince Arthur of Connaught opened the Hall of Memory on Broad Street on this day. It cost £60,000 and the money was raised from public donations. A stone panel inside states that 12,320 citizens lost their lives in the First World War.

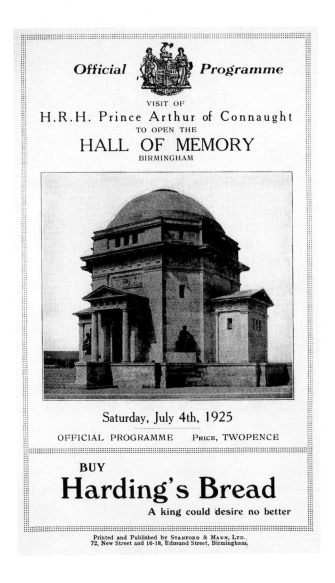

5 JULY 1880

Joseph Hughes a nineteen-year-old labourer of Oak Terrace, Icknield Port Road, was charged with violently assaulting a man from Smethwick and also willfully damaging the fencing of St Cuthbert's Church, Heath Street. Passers by saw him wrench a paling from the fence. The verger said he didn't wish to press the charge against the prisoner, but he wished the church property to be protected. He was told, 'it was no use the rector writing to the police for protection if on the first occasion you have a charge against an offender you beg him off.'

6 JULY 1914

Joseph Chamberlain who passed away on 2 July was buried at Key Hill Cemetery. The Prime Minister Herbert Asquith led the tributes from around the world, saying, 'In that striking personality, vivid, masterful, resolute, tenacious, there were no blurred or nebulous outlines, there were no relaxed fibres, there were no moods of doubt and hesitation, there were no pauses of lethargy or fear.' His family declined a burial in Westminster Abbey and opted for a Unitarian burial in Key Hill.

7 JULY 1906

Around 15,000 people attended a ceremony in Summerfield Park to mark the seventieth birthday of Joseph Chamberlain who toured the park in an open top car.

8 JULY 1938

The logbook of St Peter's School records, 'A consignment of badges and brooches, bearing the Arms of the City, has been received today. These badges are to be distributed to each child in school – for next week Birmingham will be celebrating its Centenary. Streets and buildings are already tastefully decorated.'

9 JULY 1965

John Hobson of 59 Nelson Street became the 6,000th person in the year to receive the keys to a new council home in Birmingham. He is pictured with Cllr Doris Fisher (right) and lettings clerk Mrs Lane. John, 71, and his 64-year-old-wife, Edith, had lived in the same house for 44 years and were about to move into a third floor flat at 20 Wells Tower. Apparently, he told the press, 'it's just beautiful. You couldn't find a better home anywhere.'

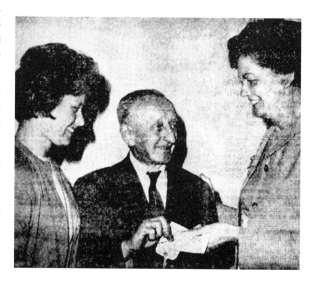

10 JULY 1935

A Nottingham architect won the scheme to design the first part of the new Civic Centre on Broad Street. This became Baskerville House which still stands today.

11 JULY 1980

The decision was made to close the annexe to Ladywood School, the former Follett Osler School.

12 JULY 1962

According to the St George's Primary School logbook a presentation was made to 'Dr S. Tomkins who has been traffic warden at the Plough & Harrow Road crossing of Monument Road for the last eight years. During that time he has never been absent from his post. This is a splendid record and we are grateful to him for his help.'

A warden crossing children over the road near St George's School, 1953.

13 JULY 1933

St Peter's Church off Broad Street was consecrated, 147 years after being built. When it was demolished in 1969, local man Barry McLaren rescued this enamel sign from a nearby wall. He recently presented it to the Ladywood History Group where it takes pride of place in the artefacts collection. Have you memorabilia that you can donate?

14 JULY 1880

Annie Green, 44, Tindal Street, Ladywood, was charged with having stolen a child's hat from the shop of Mrs Larkins, a milliner, of 205 Broad Street. Mrs Larkins said she was 'violent and made use of very bad language.' It was stated that she had 'a habit of going into shops and taking what she wanted, and if interfered with by the owners would knock them down.' The prisoner, 'a strong looking woman,' was sent to gaol for a month.

15 JULY 1966

Barford Secondary Boys' School closed to transfer to Stanmore. All the premises formerly occupied by the school were taken over by the primary school. On the same day Mr Pillinger retired from the headship of St George's School.

16 JULY 1916

This was one of the blackest days in British history, the day when things went disastrously wrong during the First World War, at the Battle of the Somme. Many hundreds of men from the Royal Warwickshire Regiment were caught up in it and in subsequent battles across the Western Front.

Arthur Gill, a former pupil of Steward Street School, and a member of the King's Rifle Corps, won a VC at Delville Wood in July 1916. During the fighting which took place it was reported, 'Sergeant Gill stood boldly up in order to direct the fire of his men. He was killed almost at once, but his gallant action held up the enemy advance.'

Gordon Highlander men, most of whom would have been from north-east Scotland, were billeted overnight at Bingley Hall on Broad Street turning the hall into a makeshift dormitory as they headed for the killing fields of France.

17 JULY 2004

Actor and wrestler Pat Roach died on this day. He will be remembered by older people as a wrestler, but he later carved out a career as an actor. His most famous acting role was that of brick-layer Bomber Busbridge in *Auf Wiedersehen, Pet*. He also appeared in numerous films including a couple of Indiana Jones flicks.

18 JULY 1929

A fire broke out at Crown Cinema on Icknield Port Road, causing the building to be evacuated. The *Birmingham Gazette* reported, 'With the orchestra playing, and without the slightest suggestion of panic, an audience of more than 400 people quietly walked out. It reopened shortly after the occurrence and the entertainment continued.'

19 JULY 1993

Bucknall Austin, quantity surveyors in Scotland Street, won a £25million contract to manage the restoration of the fire-damaged Windsor Castle. They were also heavily involved in developing the International Convention Centre.

20 JULY 1989

Employment Secretary, Norman Fowler MP, praised the Birmingham Mint for forging links with Ladywood School in training young people for the future, and he unveiled a plaque to mark completion of a £3million redevelopment of the factory. 'This company holds a very special place in the hearts of local people,' he said.

21 JULY 1972

Ladywood's secondary school, Follett Osler Secondary Modern, closed and was replaced by Ladywood School on a nearby site. Mr Cecil Jones, art master for twenty-four years, and Mr Harry Rolan who taught there for forty-seven years before retiring ten years earlier, returned to the school for the final day. Although little did anyone know at the time it was to reopen as an emergency annexe at a later date.

22 JULY 1948

The Barford Infants' School logbook notes that they, 'Rang up meals department to report that no pudding was sent for today's dinner although cook was notified by telephone of the omission.'

23 JULY 1963

The city council announced, 'In eight years' time, at its current rate of progress Birmingham expects to have demolished all of the properties taken over in its first big slum clearance project at the end of the war.' The council further announced that another 180 unfit houses were to be added to the demolition list, including some on Monument Road.

24 JULY 1986

Cllr Pat Sever, Chairman of the International Convention Centre committee, started the ceremonial first demolition of a block of buildings on Broad Street to signify the start of the Broad Street Redevelopment programme.

25 JULY 1935

Workers from Henry Wiggins' went on their centenary outing all showing 'a smile of pleasant anticipation' as they boarded coaches for Blackpool.

26 JULY 1877

Four boys were drowned at the reservoir.

27 JULY 1959

The Birmingham's Entertainment in the Parks brochure states, 'The world renowned' Dagenham Girl Pipers would be appearing on the bandstand in Summerfield Park on 27 and 28 July 1959.

27/28 JULY 1942

A roll of honour from the works magazine. During the night of 27/28 July 1942 a severe bombing raid resulted in the death of four fire fighters at the Docker Bros paint factory on Rotton Park Street. They were killed when a wall collapsed on them. They were members of the brigade from the neighbouring company of Henry Wiggins'. Later a fifth man was killed when an incendiary bomb fell nearby and he died from his injuries. The five were Bill Griffin, Bill Russell, Harry Norgrove, Bill Field and Bill Fitzpatrick and their deaths were recorded in the Wiggins' magazine. At that time Docker's was involved in the production of camouflage paint. One other person who was killed in the neighbourhood that night was Miss Priestman who had retired from teaching at Barford Road Infants' School just four days earlier.

29 JULY 1961

George Dixon School pupils went on a week-long visit to see the training ship *Foudroyant* anchored in Portsmouth Harbour.

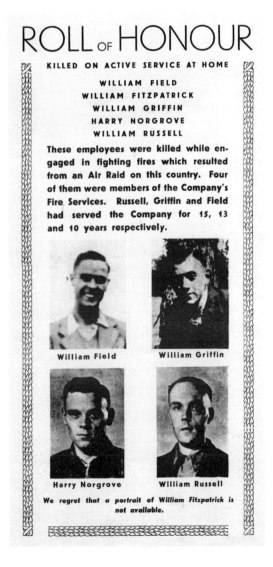

ROLL of HONOUR

KILLED ON ACTIVE SERVICE AT HOME

WILLIAM FIELD
WILLIAM FITZPATRICK
WILLIAM GRIFFIN
HARRY NORGROVE
WILLIAM RUSSELL

These employees were killed while engaged in fighting fires which resulted from an Air Raid on this country. Four of them were members of the Company's Fire Services. Russell, Griffin and Field had served the Company for 15, 13 and 10 years respectively.

William Field William Griffin

Harry Norgrove William Russell

We regret that a portrait of William Fitzpatrick is not available.

30 JULY 1841

The consecration ceremony was held at St Mark's Church, King Edward's Road. The first stone was laid in March 1840. The rare interior view below is undated.

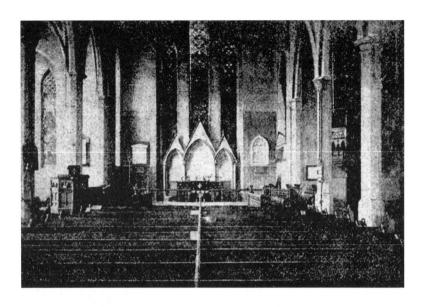

31 JULY 1876

Summerfield Park was opened on this day. The police band played the National Anthem, after which the guests took tea and inspected the park.

Summerfield Park, c. 1967. (Les While Collection)

AUGUST

Rann Street Gospel Hall on 13 August 1957.

1 AUGUST 1963

The Anchor pub, at the junction of Tennant Street and Islington Row (pictured below in July 1957), closed in 1961 and it was replaced by the trendy Auchinleck Square shopping centre. The new development included the Crusader pub that opened on 1 August 1963. It was built on the same spot as the Anchor. Now the area is once again up for redevelopment and the Crusader has closed.

2 AUGUST 1935

The local press reported that Bank Holiday is 'nearly upon us and the bears and monkeys at the Botanical Gardens are ready to amuse their visitors. The little monkeys, of course, are the star performers. They are accomplished acrobats, and incredibly light in their movements as they leap from side to side of their enclosures.'

BOTANICAL GARDENS, EDGBASTON.

3 AUGUST 1936

The Tower Ballroom was advertising itself in the local press as the 'new' Tower Ballroom. There was a special novice foxtrot competition for dancers who had not won a prize at the tower in last two months (I bet the two-left-footed blokes were falling over themselves to win that!).

4 AUGUST 1980

The Mint began dispatching the first of around 12,000 medals to commemorate the eightieth birthday of the Queen Mother.

5 AUGUST 1996

Work began on filming a BBC drama of *Macbeth* set on the central Ladywood housing estates with residents from the area playing key roles in the production.

6 AUGUST 1959

These large houses on Monument Road between Plough & Harrow Road and Ladywood Road (below) were due for demolition when this photograph was taken. The replacement flats were themselves demolished between 2007 and 2010.

From Five Ways to central Ladywood, 22 August 1968.

August was the traditional month for trips and outings. Above are the residents of Grosvenor Street, *c.* 1920 *(A. Bellamy)*. Below are the residents of Aberdeen Street, *c.* 1936 *(John Larvin)*.

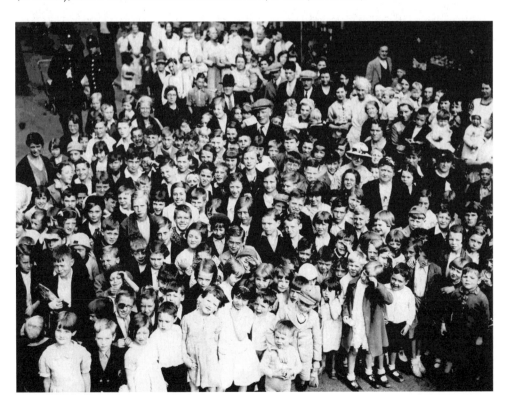

7 AUGUST 1861

Mrs and Miss Ryland who owned land on Ryland Street agreed 'to grant land as a site for a school to the Minister and Chapel Wardens of St Barnabas.'

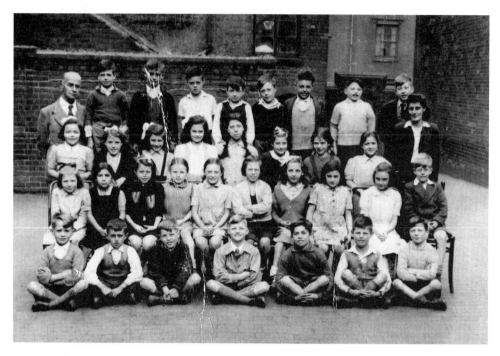

This 1946 class photograph shows, among others: Back row: Dennis Aston and Alan Meddings. Third row: Irene Ford, Joyce Lewis and Mavis Chare. Second row: Ann Price and Ann Piper. Front row: John Hipwood, Jimmy Foxall and Brian Stephens. Mr Newman the headmaster is on the top row to the left. *(Mrs Ridley)*

8 AUGUST 1900

A horse attached to a collecting cart belonging to the Corporation, and in the charge of William Hartland of Beach Street, took fright and bolted down a hill towards Smallbrook Street, despite the efforts of Hartland, who was thrown down and trampled on. The horse ran into the window of Boots' shop and was killed by the impact.

9 AUGUST 1993

The Accident Hospital on Islington Row closed on this day when services were moved to the General Hospital. The Acci' had an international reputation for plastic surgery and treating burns victims. It first opened in 1841 and the picture (opposite, top) dates from April 1953.

10 AUGUST 1874

Passenger traffic began on the New Street station to Harborne railway line. Initially there were six trains in each direction on weekdays and three on Sundays, the time taken to cover the entire journey being 25 minutes. The Sunday service was soon stopped as Hagley Road residents objected to the disturbance of their Sabbath.

11 AUGUST 1890

On this day Cardinal John Henry Newman of the Oratory Church died. On the day of his funeral thousands of people lined the route from the church to the retreat at Rednal where he was buried.

12 AUGUST 1889

There was a heavy and destructive thunderstorm over Birmingham. The press reported damage in Grosvenor Street West at the mission hall and 'residents fled in much consternation'. One man living in Icknield Port Road:

> was in the act of rising a knife to his mouth when a flash of lightning passed along the blade and severely burned his cheek. He was informed that the sight of one of his eyes maybe affected. A girl living in Brookfields, was wheeling a perambulator down the thoroughfare in which she lives, when she was struck by lightning. The current seems to have passed from her head down the left side of her body, tearing her clothing. Singular to say, the lightning cut the crown clean from her hat, leaving the rim intact. Her face was charred, and the hair singed off her head.

13 AUGUST 1962

This panoramic view of the Chamberlain Gardens appeared in the press on 13 August 1962. The paper noted it 'is one of Birmingham's most ambitious housing schemes and the preservation of trees is a feature of the planning. The scheme is expected to cost around £1,500,000 and will provide 500 homes. The first of seven 9-storey blocks is expected to be completed in the next two months.'

14 AUGUST 1993

Former Ladywood school pupil Frankie Bennett made his first-team debut for Southampton coming on in the 78th minute against Everton, playing alongside Matt Le Tissier and Ian Dowie at The Dell. The Saints lost 2–0.

15 AUGUST 1996

The local press reported that, 'Brummies are fast turning on to the idea of loft living in booming Brindleyplace.' A developer converted an old grain warehouse, which had been empty for thirty years into thirty-four apartments.

16 AUGUST 1940

According to the St Peter's School logbook, 'During this week Birmingham has had its first air raid sirens sounding at night. Consequently this week's attendance has been materially affected.'

17 AUGUST 1901

Under the heading 'More Taxpayers' Money Fooled Away', The *Birmingham Planet* magazine stated, 'Another specimen of fooling with the ratepayers money is that in connection with the roadway in Broad Street near Ryland Street. Within the last three months it has been pulled up twice and re-laid. What a waste of money! There is Councillor Bowater, his place of business is near enough for him to have noticed it.' He was a dentist who got his teeth into local politics and became Lord Mayor during the First World War.

18 AUGUST 1977

The Ladywood by-election took place following the resignation of Brian Walden. John Sever with 53 per cent of the votes retained the safe Labour seat. He remained MP until 1983. He is pictured here during a 1977 community clean-up, proving an MP can make sense even when he is talking rubbish!

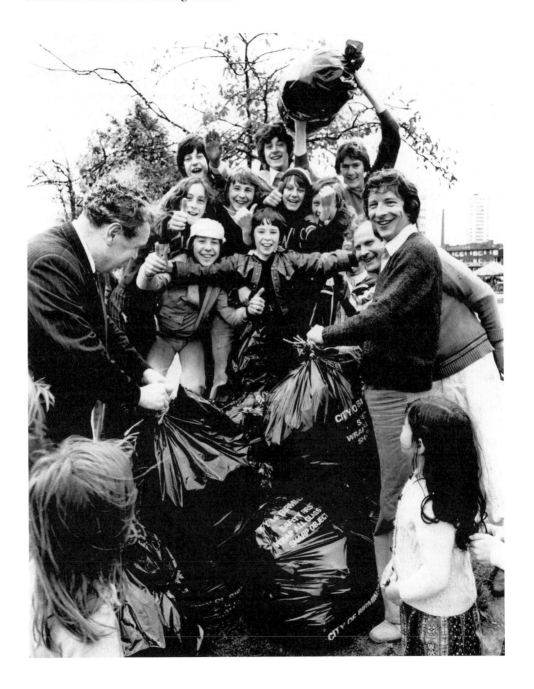

19 AUGUST 1951

The Midland Red bus garage opened on Sheepcote Street and contained offices, workshops, stores and a canteen as well as seventy buses. The garage passed to WMPTE in 1973 and eventually closed and was demolished.

20 AUGUST 1878

F. Betteridge skated into the record books, covering 200 miles in 24 hours at Bingley Hall.

21 AUGUST 1923

A fire engine and Midland Red bus were involved in a collision at the junction of Broad Street and Sheepcote Street. Three fireman and five bus passengers were taken to hospital. 'The front of the omnibus struck the fire engine broadside on and the steering gear of the omnibus was disorganised.'

22 AUGUST 1880

Three boys, named James Roberts, Frederick Gibbs, and William Hillman, all living in Ladywood, were arrested and charged with shooting stones from a catapult in Clarendon Road. Several lamps were broken. The following day they appeared in court and were fined. The court heard there was 'no other means of suppressing the nuisance which was as dangerous to life as it was destructive to property.'

23 AUGUST 2001

Robertson's Jam announced the end of the line for the golly mascot after ninety-one years. H.W. Miller at 114–16 & 118 Branston Street in the Jewellery Quarter made the original badges, before moving to Hylton Street. In the post-war boom other firms in the area, including Fattorinis, W.O. Lewis, Richard Gomm and Gaunts, made thousands of the highly collectable badges.

24 AUGUST 1907

The death of William Butler of M & B brewery fame occurred on this day. 'Congestion became a serious matter to the extent that several women and children fainted and had to receive medical attention' as they lined the funeral route from his home in Selly Park to Key Hill Cemetery. He was 'popular with the working class and a keen working man.'

The towers of the original Butler's Broad Street brewery store can be seen in this photograph dated September 1979.

25 AUGUST 1901

The Clark Street Adult School opened a branch on Bishopsgate Street. It provided Sunday lessons with a 'goal to alert and enlighten citizens'. The promotional booklet stated, 'It does not "teach" religion or economics or anything else; it invites them into a group where, by associated study of the Bible, of social ethics, and simple forms of art like music, poetry, and drama, and by such physical recreations as cricket, football, camping etc, the whole man, body, mind and spirit, is enlarged and vivified.'

WE ARE OPENING A BRANCH

OF

CLARK STREET SCHOOL

FOR

WORKING MEN

Next Sunday, August 25th, 1901,

At 9 o'clock in the morning.

THE ROOM IS IN

No. 12 Court, Bishopsgate Street,

JUST BELOW TENNANT STREET.

We shall work on Clark Street lines. Will teach you to read, write, work out sums, or help you to improve yourself in any way you like to the best of our ability. We shall have some good singing ; everybody likes good hearty singing. Some of our Clark Street men will be there with their fiddles and other instruments to give us a good start.

Never mind your coat and collar—WE WANT TO SEE YOU, not your coat. Don't stop to black your boots, come just as you are. There will not be room for any " swells " in the School. The quality of the pudding is only proved by testing it, so if you don't know what sort of a time we get at our School COME ALONG ON SUNDAY MORNING and try to bring a friend with you. If you like the sample you will come again.

HENRY CLARKE, ⎫ *Superintendents,*
E. J. FULLWOOD, ⎬ *Clark Street*
CHARLES SKINNER. ⎭ *Schools.*

26 AUGUST 1898

The George Dixon Higher Grade School moved from Bridge Street to Oozells Street. This building is now the Ikon Gallery. George Dixon School moved to City Road in 1906.

27 AUGUST 1948

A dinner and concert was held at the Botanical Gardens to mark the seventieth birthday of Walter H. Bulpitt. He had been at the firm for fifty-five years. At the function were 220 staff and employees of over fifteen years' service. The local press noted:

> The company has 1,000 employees at its three works making aluminium and electrical domestic utensils and appliances. It was founded in 1870 by the present chairman's grandfather, Mr Thomas Bulpitt to make percussion cap boxes for the Franco-Prussian War. Later, it turned to the manufacture of tinware, and its history has been a mixture of production for war and peace. Early in the century, cordite cases were made for the admiralty, for whom the company later did torpedo work in both World Wars.

28 AUGUST 1880

Eleven-year-old Alfred Hopkins was 'rather seriously injured' when crossing Hagley Road. A horse and cab, coming from the direction of the Plough & Harrow, knocked him down before he could get out of the way. The child was picked up and taken to the Queen's Hospital where it was found he had sustained a scalp wound and a large lacerated wound on the right arm.

29 AUGUST 1927

Thomas Palmer aged nineteen of 1 back of 26 Camden Street, an aluminium polisher, was charged with unlawfully and maliciously inflicting grievous bodily harm on Frank Davies of 56 Edward Street, Parade. The two men were in the King Edward VI public house on 5 August when suddenly owing to a fusing of an electric wire, the light went out. Simultaneously with this, it was alleged Palmer picked up a half-pint glass and threw it at Davies, inflicting injuries to his eye. Palmer claimed he wasn't in the public house when the lights went out. He was sentenced to six weeks' hard labour.

30 AUGUST 1947

This day marked the end of tram route 33 which ran from Icknield Port Road to the city centre. It was replaced by the 95 bus which later became the 43 then 66 and is now the no. 80!

31 AUGUST 1944

According to the St George's Primary School logbook, 'After 44 years' service in this school Miss Salmon retires today. Hers is a unique record and the children of the school paid their tribute to Miss Salmon by presenting a cheque and loving wishes for her happiness.'

ALSO IN AUGUST

Birmingham held a 'Blackpool Week' over six days in August 1932, complete with miniature tower and beach. The star attraction was Bert Powsey, 'The world's greatest high diver' who leapt from an 80ft tower . . . tied up in a burning sack!

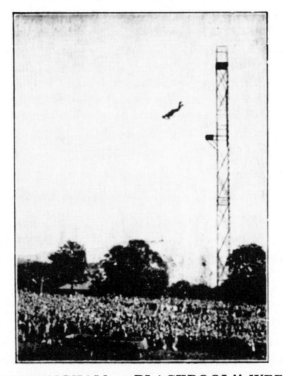

THE WORLD'S GREATEST HIGH DIVER.

BIRMINGHAM "BLACKPOOL" WEEK
. . Presents . .
FOR THE FIRST TIME IN BIRMINGHAM.
BERT POWSEY,
HE WILL DIVE FROM THE DAM
at 3 o'clock and 5-30 p.m.
AND MAKE HIS
LEAP FOR LIFE at 10-15 p.m.
FROM TOWER ON SOUTH SHORE.

DARING DIVING

Some of the most spectacular items on the programme are provided by the daring Bert Powsey who seems to take a huge delight in risking his life in feats of high diving. Not content with just high diving—such a performance would no doubt seem tame to him—he dives from an 80 ft. tower, tied up in a sack which is set on fire just before he leaps; and just to add a little more excitement to this particular feat he dives—not into the reservoir, but into a blazing cauldron which is only 4ft. deep.

Another episode reveals Mr. Powsey out for a cycle ride—but here again he's not content with the ordinary joys of cycling. He adds to these a little thrill by riding along a plank high in the air—and into the reservoir. Not too good for the bicycle true, but no doubt it satisfied this amazing man's appetite for adventure.

It is interesting to note that for this latter feat, Mr. Powsey insists upon a Bicycle of local manufacture—a B.S.A. Bicycle. A machine that has to stand the buffetings and continual soakings that he subjects it to, must be strongly built and well designed, and there is no doubt that he has chosen the most suitable machine for his purpose.

We don't advise other owners of B.S.A. Bicycles to emulate Mr. Powsey. No doubt their machines would emerge quite unaffected by the attempt—but whether the rider would is open to question.

SEPTEMBER

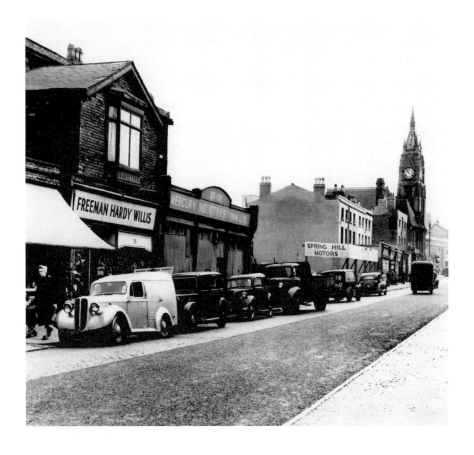

Spring Hill, September 1951.

1 SEPTEMBER 1939

According to the Nelson Street School logbook, 'On 1 September seventy children were evacuated to the country villages around Bromyard. They were distributed among seven villages. Stoke Lacey, Hereford, received the largest number.'

2 SEPTEMBER 2007

Jasper Carrott followed Ozzy Osbourne and became the second person to be inducted on to the Broad Street Walk of Stars. He unveiled his star on a stage in Centenary Square with fellow Birmingham City supporter, the Lord Mayor, Cllr Randal Brew.

3 SEPTEMBER 1970

The new school of St Edmund's was opened in Brookfields. It was a replacement for the old school of St Peter's in Broad Street and should have retained the same name, but as there is a St Peter's Church of England nearby, the new name was substituted in order to avoid confusion.

4 SEPTEMBER 1993

Former Ladywood School pupil Asif Din scored 104 and was made Man of the Match as his Warwickshire side beat Sussex in the Nat West Trophy final at Lord's cricket ground.

5 SEPTEMBER 2007

A First World War bomb, used as a doorstop, was discovered at the premises of Chidlow's in Steward Street. The bomb squad was called and the bomb taken away and destroyed.

6 SEPTEMBER 1972

Ladywood School opened taking pupils from three old schools, Camden Girls', Icknield Boys' and Follett Osler. In addition pupils transferred from fourteen primary schools. Sadly, owing to a builders' strike, the new school was not completed so the old Osler Street building was reopened even though parts of it had been vandalised during the holiday and there is was no heating system, no hot water and the minimum of light and power – but the headteacher noted, 'Despite this the school has settled in quite well.' This also the date in 1873 when Blondin walked across a tightrope on Edgbaston Reservoir.

7 SEPTEMBER 1936

The local press reported that thirteen-year-old Stanley Sabell of Ingleby Street dived into the canal near Northbrook Street bridge to rescue ten-year-old William Gannon of King Edward's Road. William had been walking on girders of the bridge but slipped and fell 26ft into the water.

8 SEPTEMBER 2009

A DVD *Ladywood at War* was launched at a special showing in the Central Library Theatre. Youngsters from TNT News, run by the Ladywood Video Club, interviewed many people about their wartime experiences and even visited the beaches at Dunkirk and Pegasus Bridge in France where they met Madame Arlette Gondrée who was a youngster sheltering in her parents café when the D-Day invasion took place. She is now patron of the Birmingham branch of the Normandy Veterans' Association.

TNT News presenters Callum Kenney and Alex Pawlowski hand over a copy of their work to Madame Arlette outside her café. *(www.tntnews.co.uk)*

9 SEPTEMBER 1981

At Ladywood School there occurred a 'Meeting to discuss Richard Lindsay's success as National Frisby Champion, and his proposed visit to Dallas for a week in October.' Filmed by ATV on the 10th.

10 SEPTEMBER 1890

According to the Osler Street Boys' School logbook, 'So great was the noise created by the vigorous ringing of a handbell in the street and under the windows of the Boys' department that the reading of the Bible was a dumb show. This bell is frequently ringing almost continuously by one of the teachers of the Girls' department.'

11 SEPTEMBER 1963

The Barford Primary School logbook records that, 'The junior boys commenced a football team to play against other schools. Uniform pullovers being bought out of school fund. Yellow trimmed royal blue, socks reverse colours with royal blue shorts and school badge on pullovers.'

12 SEPTEMBER 1984

Geoffrey Lloyd, Conservative MP for Ladywood 1931–45, died on this day. In 1931 he had majority of 14,000. He lost to Victor Yates in the first post-war election. He later became MP for King's Norton, then Sutton Coldfield.

13 SEPTEMBER 1951

Col. Sir William Henry Wiggin of Callow End died aged sixty-three. He was a former managing director of Henry Wiggin Ltd of Wiggin Street, a major nickel and copper metalworking concern employing thousands of local workers.

14 SEPTEMBER 1800

The toll gate at Five Ways stood from 1773 to 1841. In September 1800, 'It was resolved to keep the Five Ways toll gate in the Hands of the Trustees for the ensuing years and that Thomas Toy be appointed keeper at a salary of 21/- per week.'

15 SEPTEMBER 1893

The logbook of Nelson Boys' School on 15 September 1893 records, 'The school, was placed second in the Annual Dumb-bell Competition open to all Elementary Schools in the City; also second, in the Championship Gymnastics Exercises.'

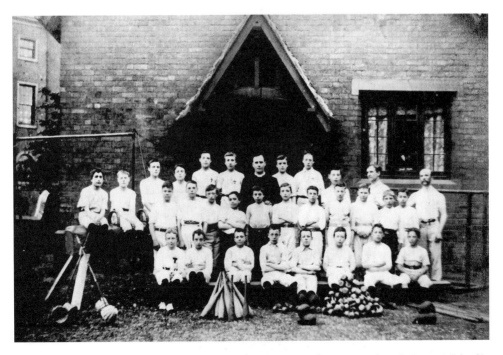

Gymnastic events were popular lessons in all schools and this group of gymnasts is from St George's School in 1887. *(St George's School archive)*

16 SEPTEMBER 1953

The death occurred of Thomas Arnold, aged eighty-three, a well-known grocer who had shops on Monument Road and Hagley Road near the Ivy Bush. The *Birmingham Post* noted he was, 'very well known in the grocery trade, he expanded a small business into nine shops in Edgbaston and Sutton Coldfield. He was chairman of the Birmingham & District Retail Grocers' Association during the First World War and later became president of the National Federation of Grocers' Associations.'

Arnold's adverts from 1945.

17 SEPTEMBER 1900

There was as a serious fire at the Eclipse Tyre & Rim Co. in Cumberland Street. The tender, steamer and escape were all sent to the scene. 'The premises were slightly injured by water.'

18 SEPTEMBER 1940

The local press stated, 'This Messerschmitt arrived in Birmingham today for an exhibition at the Civic Centre to stimulate interest in the Lord Mayor's Spitfire Fund. The plane, which recently came down in a Sussex village, is being displayed on the colonnade of the Birmingham Hall of Memory until the end of September,'(see photograph opposite, top).

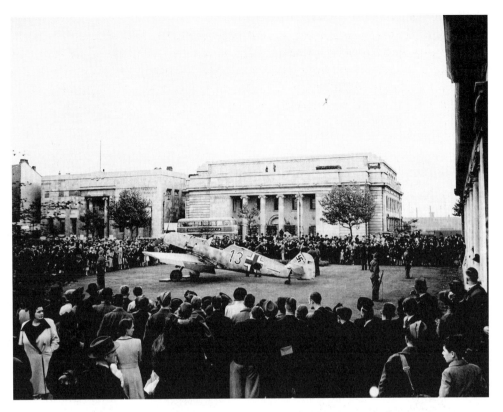

(Local Studies Library and www.digital-ladywood.org)

19 SEPTEMBER 2010

Pope Benedict XVI visited the Oratory Church, Hagley Road, to see the room and shrine of Cardinal Newman. Earlier in the day he beatified Newman at a mass in Cofton Park, moving Newman one step closer to being made a Saint. The Pope's visit to the Oratory was essentially a private visit, albeit watched over by thousands of people who lined Hagley Road to see him in the Popemobile.

20 SEPTEMBER 1906

The headteacher of St Barnabas Girls' School wrote to the manager of an adjoining works to complain about their workers. 'Many women and girls have shouted out of the windows, mocked teachers, when teachers have been getting children from play.' The manager called and apologised for the annoyance.

21 SEPTEMBER 1917

The City Road Infants' School logbook notes, 'Harvest Festival tea. 16 baskets of fruit, flowers, cakes presented by scholars to Southern General Hospital Wounded Soldiers. Many grateful letters.'

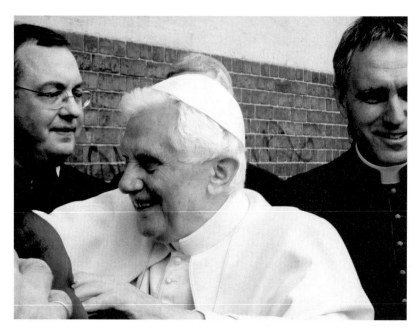

Pictures of Pope Benedict XVI's visit to the Oratory on 19 September 2010. *(Sarah Hall)*

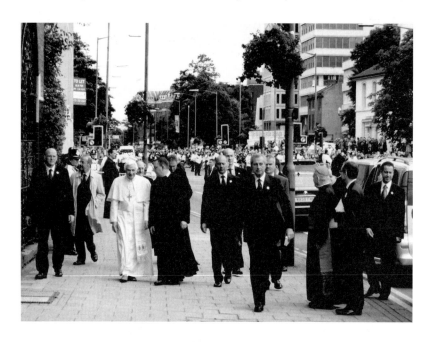

22 SEPTEMBER 1919

The Lyric Picture House opened on Edward Street, in the former Church of the Saviour. The first film shown was called *Wheel of Life*.

23 SEPTEMBER 1988

Swimmer Nick Gillingham, who trained at Monument Road baths, powered his way to glory winning the silver medal and breaking the British record in the 200 metres breaststroke final at the Seoul Olympics.

24 SEPTEMBER 1891

According to the St Mark's School logbook, 'A woman complained about Mr — severely thrashing her boy. I saw the boy stripped and found his flesh very badly bruised. The mother was very disturbed to summon the teacher. She immediately came back having seen the doctor who told her the treatment was brutal but advised her not to go to court. The teacher promised to do something for the boy.'

25 SEPTEMBER 1990

The Oratory School logbook notes that 'Year 6 visited Aston University to take part in a radio broadcast hosted by Johnny Ball the TV personality.'

26 SEPTEMBER 1879

The Osler Street School logbook notes, 'The Onion and Horse Fair held in the town. Very wet in the middle of the week.'

27 SEPTEMBER 1970

The Royal Mint pub at the corner of Icknield Street and Hingeston Street closed. The father of actor Tony Britton was once the licensee.

28 SEPTEMBER 1971

The Warstone pub closed on this day. The photograph below shows it in August 1967 from the corner of Icknield Street looking down Camden Street.

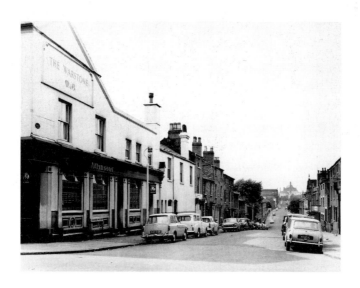

29 SEPTEMBER 1993

The digging of the foundations on the £250 million Brindleyplace development began with the help of the JCB digger show. Also on show was this dance group with a Tina Turner look-alike who assumed she was 'Simply the Best'.

30 SEPTEMBER 1940

According to the St Peter's School logbook, 'On Wednesday afternoon the children spent a thrilling hour in the playground while they watched Alec Henshaw work wonders with a Spitfire. It certainly was a marvellous display. Earlier in the day, a captured Messerschmitt was placed outside the Hall of Memory. Needless to say most of these children had visited the exhibit during the afternoon.'

A selection of local adverts from September 1979.

Veteran bandleader Les Douglas was special guest at the Tower Ballroom at a 1940s-style Blitz Ball in September 2010, organised by the Old Ladywood Reunion Association. The event raised £5,000 for BBC Radio WM's Kidney Kids Appeal.

Members of the Old Ladywood Reunion Association visited the new Children's Hospital to hand over a cheque to buy equipment for the Kidney Ward, the proceeds of a charity Blitz Ball that was held at the Tower Ballroom. Pictured are Stan Wood, Tony Higgs, Ralph Hickman, Norma Wood, Audrey Banner and Val and Gordon Cull with young patient Mckenzie who was awaiting an operation.

OCTOBER

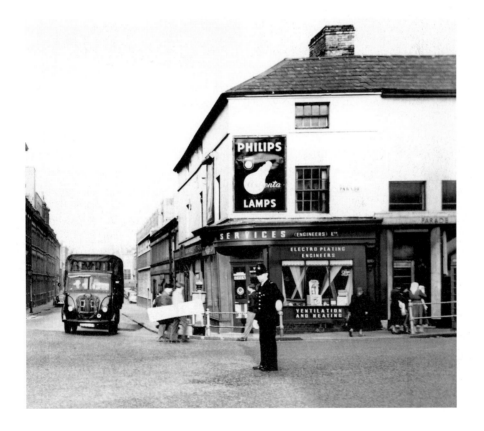

At the junction of the Parade and George Street, October 1954.

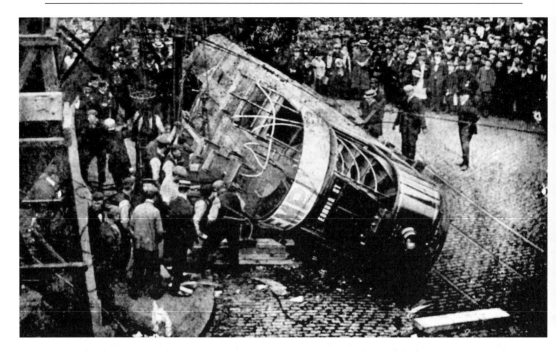

1 OCTOBER 1907

Two people were killed and nineteen injured in Warstone Lane in Birmingham's worst ever tram crash. The cause of the crash was brake failure and the tram toppled over at the bottom of the hill after gathering speed coming down from the Chamberlain clock.

2 OCTOBER 1875

St Margaret's Church was consecrated on this day. The church stood at the junction opposite Ledsam Street and Great Tindal Street.

Baptism certificate for Jane Stiles,
June 1877, at St Margaret's Church.

122

3 OCTOBER 1902

According to the St Barnabas Girls' School logbook, 'On Wednesday afternoon the round window at the end of the schoolroom fell in, fortunately hurting no one ... since then the wind has been very cold, and in that quarter, it has been impossible to teach Standard V, VII, VIII in their normal place. Teachers and children have suffered very much from the keenness of the wind blowing through the open space and may have very bad colds.'

4 OCTOBER 1991

Linford Christie officially opened the National Indoor Arena. The huge structure spans 130 metres by 90 metres and the running track is directly over a 125-metre long tunnel which encloses the main Birmingham to Wolverhampton railway line.

5 OCTOBER 1932

The official opening of the Salvage Department on Rotton Park Street was held on this day. The rubbish event was presided over by Alderman Sir Frederick Smith, chairman of the Salvage Committee.

6 OCTOBER 1882

The *Building News* reproduced this design that had been approved for the Dispensary to be built on Monument Road by Payne and Talbot. The building eventually became Ladywood Community Centre before being replaced by a grass verge, which lacks the architectural excellence of this building.

LADYWOOD BRANCH DISPENSARY
BIRMINGHAM

ACCEPTED DESIGN

PAYNE AND TALBOT
ARCHITECTS
BIRMINGHAM

7 OCTOBER 1966

The Lord Mayor opened the new police station on Ladywood Middleway. The £140,000 development was described as 'Birmingham's most modern police station' and it replaced one of the city's oldest stations, which had been operating from Ladywood Road since 1859.

8 OCTOBER 1965

The keys to a top-floor flat in Birmingham's tallest block of flats, Charlecote Tower, Cregoe Street, were handed over to sixty-seven-year-old Emily Vann, who moved there from William Street. She admitted to wanting a ground floor flat because she was worried about the lift but the PR blurb, said she was now 'happy with her choice'. She added, 'In William Street we never had a bath, we have had to heat water on a stove and pour it into a metal bath. This will be heaven.' She was nearer to heaven in more ways than one!

Mrs Vann and housing officials with the remains of St Thomas' Church at ground level.

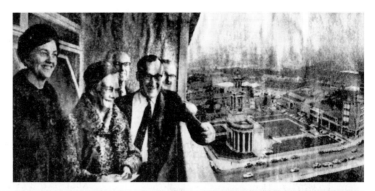

The official opening of Summerhill Works on 8 October 1984. *(Bernard Fagan)*

8 OCTOBER 1984

The opening of the new Rabone Chesterman premises at Summerhill on the site of the former Bulpitt & Sons factory took place.

9 OCTOBER 2001

A report from Ladywood's video news channel TNT was shown on Channel 4's *First Edition* programme with Jon Snow. It looked at the problems of tackling bogus callers which at that time was a problem on some estates.

10 OCTOBER 1859

At the Birmingham Police Court, a butcher, John Richards of Spring Hill, was fined 20s, or one month's imprisonment, for 'exposing the carcase of an unsound pig, and sixty pieces of bad beef, mutton and lamb.'

11 OCTOBER 1945

Victor Yates MP made his first recorded contribution in Parliament. He asked the Minister of Health if he was aware that 'insanitary conditions in many parts of Birmingham have become intolerable' and as an example he highlighted the fact that 'in Nelson Street, only one lavatory is available for 36 persons.' The Minister replied, 'I am aware that many occupied houses in Birmingham, as elsewhere, are in a very bad condition. The Corporation are doing their best to improve matters, but this is dependent on labour and materials.'

12 OCTOBER 1914

Officers of the Royal Warwickshire Regiment moved into temporary accommodation in the Plough & Harrow Hotel on Hagley Road.

13 OCTOBER 2002

A reopening service took place at St John's Church after a major restoration programme during which the traditional pews were replaced by flexible seating.

14 OCTOBER 1919
The city released this photograph of Broad Street at the junction with Easy Row, which was to become the location of the new Hall of Memory. According to the *Birmingham Mail*, 'The properties are to be purchased at a cost of £144,000.'

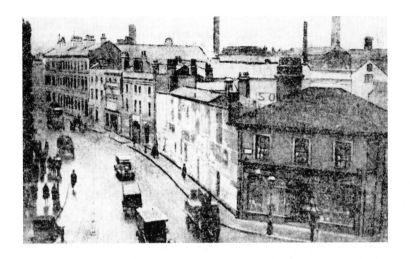

15 OCTOBER 1929
According to the Nelson Boys' School logbook, 'All boys were allowed to go into the playground at 10.45 a.m. for about ten minutes to see the airship R101, which made a circle of the district and afforded a good view considering how surrounded with buildings the playground is.'

16 OCTOBER 1911
The Nelson Street Boys' School logbook notes that, 'At the elementary Schools Gymnastics Competition held at John Bright Street, Nelson St boys had a "walkover" in the Individual Championship. Alfred Robinson was placed first, Samuel Avery second and Edward Moore third. The work was the best yet seen at the athletic Institute.'

17 OCTOBER 1906
The Ladywood tram route 33 opened. The terminus was at the smithy next to the Wheatsheaf pub, Icknield Port Road. The route closed in 1947.

18 OCTOBER 1864
A man named Harvey Thompson Knight wrote to the press about the work of 'redtape' tax officials, who having received papers from his employers, Tangye's of Clement Street, promptly sent him three separate tax demands, one addressed to Mr Harvey, the second to Mr Thompson and the third to Mr Knight. He stated, 'After this no one will question the assiduity of our assessors or question their desire to do their best towards collecting the Queen's just dos.'

19 OCTOBER 1934

The St Peter's School logbooks notes, 'On Monday afternoon Miss Downey took the senior girls to Wathes, Cattell & Gurden dairy. There was a tour of inspection and the children were afterwards entertained to tea.'

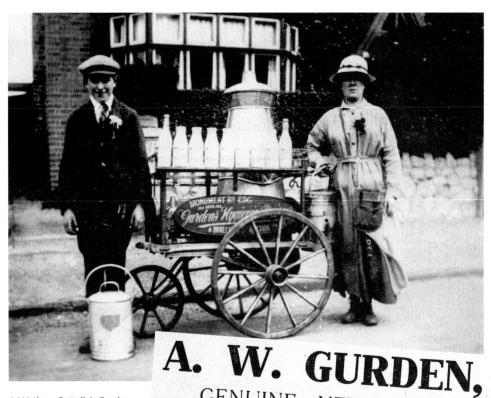

A Wathes, Cattell & Gurden milk float, date unknown, but the milk's probably gone off by now!

This advertisement is from October 1912.

A. W. GURDEN,
GENUINE NEW MILK.
FRESH BUTTER. NEW LAID EGGS.

Special Thick Cream Delivered in Hygienic Vessels. Recommended by the Medical Profession

PASTEURIZED MILK
— MEANS —
PERFECTLY PURE MILK.

We supply PASTEURIZED MILK at the same price as ordinary milk; also in

Pint Bottles, 2d. **Quart Bottles, 4d.**

Each customer's separate order put up at the Dairy and guaranteed clean and free from contamination. We claim to have the ONLY DAIRY in the West End of Birmingham fitted with the latest Improved Pasteurizing Plant. Open for inspection.

RING UP 5957 CENTRAL.

67 & 69, Marroway Street, Birmingham.

CREAMERY: ASTON HALL, STAFFORD.

20 OCTOBER 1941

The logbook of Nelson Street School states, 'This is Warship Week in Birmingham and an extra effort is to be made in school for National Savings.' They raised over £100.

21 OCTOBER 1927

According to the St Peter's School logbook, 'This morning thirteen tickets were received from the Daily Mail Fund for providing boots for poor children. There seem so many deserving cases at present that it was a difficult matter to allocate the cards.'

22 OCTOBER 1826

The first stone was laid at St Thomas's Church, Holloway Head, by the Bishop of Worcester. It was consecrated 22 October 1829 having cost £14,220.

23 OCTOBER 1940

One workman was killed and two injured when an air raid shelter they were building collapsed on them outside the Mount Pleasant Working Mens' Club on Reservoir Road. ARP wardens removed earth and had to use sledgehammers to smash concrete slabs to get to the men who were trapped for an hour and a half.

24 OCTOBER 1860

St Barnabas' Church on Ryland Street was consecrated 24 October 1860 – the foundation stone was laid on 1 August 1859.

25 OCTOBER 1965

Canon Norman Power, vicar of St John's Church, had a book published on this day called *The Forgotten People*. It explored the effect that slum clearance had on the population of the local community and received widespread attention.

26 OCTOBER 1880

The Joseph Chamberlain Memorial was unveiled in Chamberlain Square. Guests from the Ladywood area included Mr Henry Wiggin, Abraham Follett Osler and Sampson Gamgee.

27 OCTOBER 1905

The Nelson School logbook notes that a 'collection has been made this week for the Warley Woods Fund. The amount received from the scholars was 10/6d.'

28 OCTOBER 1948

The *Birmingham Post* announced the death of Mr Arthur Simpson, director of Simpson's seedsmen and corn dealers, a business established by his grandfather which at one time had sixteen branches including one on Monument Road, not far from the Chad Valley nursery. He was for many years treasurer of the Church of the Redeemer.

An advertising postcard produced by Simpson's Seeds.

29 OCTOBER 1969

The *Birmingham Evening Mail* reported, 'Demolition men are succeeding where anti-Papist rioters failed 300 years ago now that work is starting on tearing down St Peter's Roman Catholic Church in Broad Street. St Peter's closed a month ago because its structure was unsafe and will not be replaced after demolition.'

30 OCTOBER 1971

R. Grocott JP, the president of the Ladywood Social Club (1969–95), performed the opening ceremony of the new premises on Ladywood Middleway. The club moved from 268 Monument Road where it had been located since 1938.

7.00 p.m.—8.00 p.m.

RECEPTION AND MUSIC FOR YOU

8.00 p.m.

OPENING CEREMONY
By
R. H. GROCOTT, J.P.

8.30 p.m.

ARTISTES
INTRODUCED BY YOUR COMPERE
BILLY WEST

DON MACLEAN
T.V. Comedian

HOWARD JONES
Vocalist from Joe Loss Band

DOROTHY NASH
Attractive West End Vocalist

I N T E R V A L

DON MACLEAN
HOWARD JONES
DOROTHY NASH

God Save The Queen 11.45 p.m.

31 OCTOBER 1882

The St George's School logbook noted that they were 'very grieved to say that a 1st Class lad was found passing papers to other lads in the class on which he had written the foulest and filthiest language. I sent him home and have put the matter in the hands of Rev. J W Lawson.' The following week the lad was 'dismissed from the school'.

Right: Parker, Winder & Achurch of Broad Street advert from the students' carnival programme, October 1927.

Below left: The Hermetic Rubber Co. of Ryland Street, October 1958.

Below right: A brilliant Guinness advert on a billboard on Islington Row, October 1964.

THE "EAGLE" COMBINATION GRATE
MAKES WORK A PLEASURE.

BURNT CAKES WOULD'NT HAVE APPEARED IN HISTORY IF **ALFRED HAD USED ONE OF THESE GRATES.**

There is no need to die; It's warmer in front of one of these **GRATES.**

KEEP THE

(a) Cat happy.

(b) Children at home.

(c) Home fires burning.

SEE ONE AT —— **PARKER, WINDER & ACHURCH, OF BROAD STREET.**
OR WRITE FOR LIST EG 518.

REDUCE *Your* **CLEANING COSTS..**

With **HERMETIC MUD FLAPS**

BEADED ON THREE SIDES. REINFORCED WITH 2 PLIES OF CANVAS THROUGHOUT, GIVING GREATER STRENGTH AND LONGER LIFE.

HERMETIC RUBBER CO. LTD.
HERMETIC WORKS · RYLAND ST · BIRMINGHAM 16
PHONE·EDGBASTON 0983/4 *Established 1895* GRAMS·HERMETIC,BIRMINGHAM

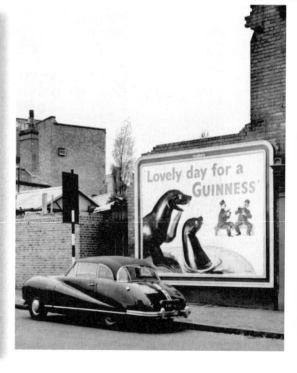

NOVEMBER

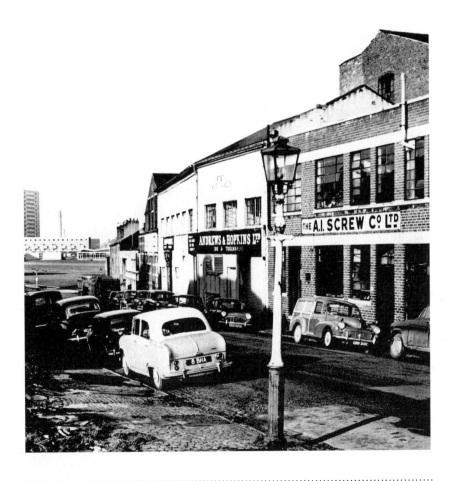

Ruston Street, November 1965.

1 NOVEMBER 1961

On a visit to Birmingham the Queen Mother made an unscheduled stop as she passed a group of well-wishers outside the Jesmond Grove Home in Highfield Road, Edgbaston, so she could speak to elderly people sitting on benches outside the home waving flags.

2 NOVEMBER 1961

Two men were hurled 90ft as a crane being used to erect flats off Francis Road 'crashed in a mass of twisted steel.' The crane was being demonstrated to insurance officials at the time of the accident.

3 NOVEMBER 1877

It was reported that the Public Works Committee had consented to change the name of Monument Lane to Monument Road and that 'Icknield Street West, between Ladywood Road and Dudley Road, shall be also be called Monument Road.' The monument after which it was renamed was Perrott's Folly.

4 NOVEMBER 1940

Birmingham was extensively bombed in November 1940. An entry in the logbook of Nelson Street School for 4 November reads, 'School reopened. During the holiday Birmingham has experienced its heaviest air attacks with heavy damage. The district around the school has suffered greatly, damage to property and loss of life in near vicinity of school.' It goes on to say that on 15 November 1940, 'Attendance very poor following an eleven hour air raid during the past night from 7.00 p.m. till 6.15 a.m.' Then, on 20 November 1940, 'the air raid last night was the worst yet experienced and lasted for nine hours. The damage both in the city and the suburbs [is] on a most extensive scale.'

5 NOVEMBER 1901

The *Midland Express* noted that, 'The annual meeting of the Birmingham & District Adult Schools Bagatelle League was held on Saturday. The second division medal for the best average for the first team went to W. Hoccum of Icknield Street and for the second team to W. Stockwin also of Icknield Street School.

6 NOVEMBER 1961

Engineering firm Archdale's, which James Archdale started in Birmingham ninety-five years ago with a staff of two boys, announced it was severing its connections with the city and moving to Blackpole, Worcestershire. 1,300 workers were expected to move as part of the company's expansion plans and limited space at Ledsam Street.

7 NOVEMBER 1888

Two Ladywood boys, Frank Horton of Alston Street and Harold Dowler of Beach Street were each fined 1s for riding their bicycles 'at a furious rate' along Broad Street where they reached speeds of 16mph 'on the wood paving which formed a smooth track for them.'

8 NOVEMBER 1912

The logbook of St Peter's School notes that, 'On Wednesday morning some thirty of the first class children paid a visit to the Chrysanthemum Show.'

9 NOVEMBER 2006

The family of the late Alfred Knight VC gathered by the new road named in his honour in Lee Bank. Knight won his VC at Ypres in 1917. He was born in Friston Street, Ladywood, and spent his retirement years near to the new road in Elvetham Road.

10 NOVEMBER 2006

The press reported the death of Sam Stocker who it was believed was the last surviving member of HMS *Dainty*, the destroyer sunk off Tobruk in 1941. He became an officer of TS *Vernon* in the early 1980s.

11 NOVEMBER 1918

Armistice Day celebrations were underway. The logbook of Nelson Street School recorded the happy event, 'On notice given by the maroons at 11 o'clock of the signing of the Armistice, work was suspended. A joint celebration by the three departments was held in the playground and school was dismissed at 11.45 a.m. to assemble in the afternoon.'

12 NOVEMBER 1987

G. Byrne, training manager of PPG Industries, formerly Docker Bros, made the presentations at Ladywood School's annual awards evening. The Alderman Boughton Award for most significant contribution to school was awarded jointly to Ian Gravenor and Emma Studley. Other awards included the Sportsman of the Year Award, which was presented to Liam Lawlor.

13 NOVEMBER 1942

This sad note was recorded in the logbook of Nelson Street School. 'News has been received that the mother of one of our scholars who has been sadly neglected has been sentenced to six months' hard labour for this neglect. The case was brought by the NSPCC.'

14 NOVEMBER 1966

The first yellow box junction in Birmingham was installed at the junction of Hagley Road and Rotton Park Road/Norfolk Road.

15 NOVEMBER 1875

Osler Street Board Boys' School opened on this day under the direction of Mr Wiseman. The logbook on that first day records, 'Each boy in the school has to buy his own slate, copy and exercise books and drawing materials.'

16 NOVEMBER 2009

This date marked the official opening of the new Summerfield police station on Icknield Port Road by the newly appointed Chief Constable of West Midlands Police, Chris Sims. He is pictured during an interview with TNT News reporters Hannah Rowley and Nikiesha Beswick.

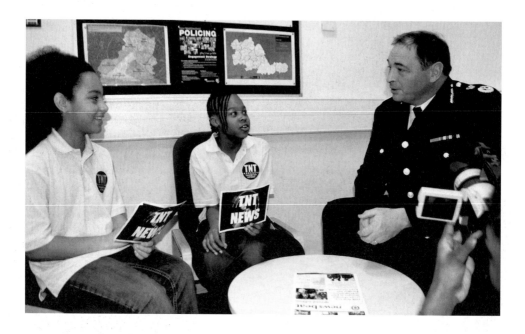

17 NOVEMBER 1998

Oozells Square at Brindleyplace was officially opened. The Victorian former Oozells Street School and one time George Dixon School is now the Ikon Gallery (see opposite).

18 NOVEMBER 1893

Andrew Griffiths, aged thirty-seven, of Hyde Road appeared in court over 'serious chastisement of a boy'. He had walked along Oliver Road when his hat was knocked off by a piece of string which had been strung across the pavement from a lamppost to some spouting. It was said that Griffiths became so angry that he 'boxed the boy's ears'.

19 NOVEMBER 1928

According to the Nelson Boys' School logbook, 'An hour was given to the Commemoration of the 100th anniversary of the death of the composer Schubert, with gramophone records, class singing, "Who is Sylvia?", and the piano, with address by the headmaster.'

20 NOVEMBER 1940

This was a time of heavy bombings as the City Road School logbook records, 'School closed today, unable to be used owing to a direct hit by high explosive bomb.'

Oozells Square.

21 NOVEMBER 1961

The 100th Birmingham Fatstock Show opened at Bingley Hall. The photograph shows judging at the 1970 show.

22 NOVEMBER 1940

The St Peter's School logbook notes that, 'After the desperate raid of Tuesday (lasting just twelve hours) most houses are left without gas and just a few without water – as both gas and water mains have been destroyed. The havoc continues and the city looks dreadful.'

23 NOVEMBER 1859

Edward Gossage, aged fifteen, was found dead and 'by his side lay, in a state of stupor, resembling death, a youth of 17, named William Garbett of Holiday Street.' They were 'houseless lads' who had slept in a hollow near Duke Street, alongside a quantity of ash from a nearby nail works which gave 'the benefit of warmth. It is supposed that some noxious gases were also generated.'

24 NOVEMBER 1934

Passenger services were withdrawn on the Harborne railway. A local paper reported, 'I walked up and down No.1 platform at New Street at 11.08 p.m., with the ghosts, and every noise was the whisper of a memory. For, standing in the station was the famous "Harborne Express", which, after running for more than 60 years, was waiting to make its last journey. It stood silent, there was not even a sigh from its funnel.'

25 NOVEMBER 1940

According to the St Peter's School logbook, 'Everybody thought we had experienced the worst – but it was necessary to wait for last Friday night's attack just to realise how diabolical the raid was. This particular district suffered badly, some of our families [were] completely wiped out. The gas and water shortage is so acute that the Educational authorities have ordered another evacuation to take immediate effect.' This was to Swannington in Leicestershire.

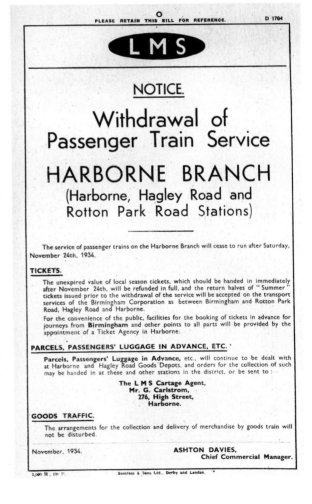

26 NOVEMBER 1926

This 68lb cabbage, the largest of the show, was displayed at the Fatstock Show opened at Bingley Hall in the presence of the Prince of Wales who gave a warm tribute to the British farmer at a luncheon given in his honour. He in turn was greeted with a chorus of 'For he's a jolly good fellow' from a huge crowd of spectators.

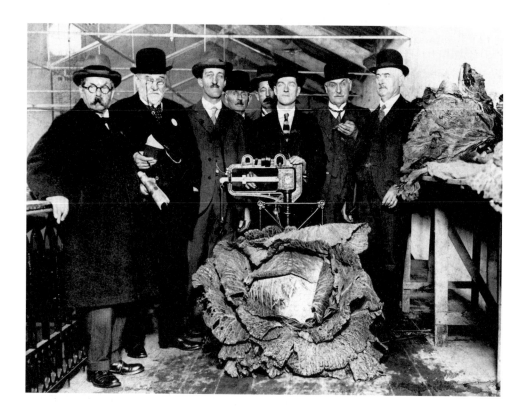

27 NOVEMBER 1875

The first teachers' meeting of the Clark Street Adult School was held at 35 Monument Road. It was decided the school would open at 9.30 a.m. on Sundays and close at 11.00 a.m. Teachers decided to open each session by reading a portion of scripture, with singing and prayer, and that time be devoted to instruction in reading and writing. It was also resolved that funds would be provided by the teachers.

28 NOVEMBER 1963

Days after the assassination of J.F. Kennedy the Birmingham weekend paper the *Planet* produced colour photographs. 'Our historic pictures are exclusive to the newspapers in this group. No other newspapers in the world, including America, have yet been able to print colour pictures of President Kennedy's funeral.' Adverts in the paper included Matty & Rhodes TVs of Broad Street, sets available from 'only 7/- per week'.

The police were advertising for recruits, constables from £635 pa rising to £1,090. The Typewriter Centre on Dudley Road was selling their wares for £14 and Camden Motors had a used Triumph Herald estate car in powder blue for £540.

29 NOVEMBER 1889

According to the Nelson Street School logbook, 'There were five or six firm slides in the yard. I examined the school in arithmetic and let out all who passed for a half hour's sliding. The boys enjoyed it very much.'

30 NOVEMBER 1887

A brakeman was knocked down and killed while crossing the line at Monument Lane station by a shunting engine 'in spite of the best efforts of the driver, who had seen the deceased, to bring his engine to a standstill.' The wheel of the locomotive crushed his arm and body 'in a shocking manner.' He died later in the Queen's Hospital, Bath Row.

The all-new Shell Spring Hill self-serve petrol station on 25 November 1970 and (below) how it looked nearly forty years later. How many changes can you spot? *(Alex Pawlowski)*

Adverts from the Birmingham students' carnival magazine in November 1952.

Adverts from the November 1969 issue of the *Christ Church Summerfield Magazine*.

Adverts from the November 1969 issue of the
Christ Church Summerfield Magazine.

DECEMBER

Commercial Street, December 1951.

1 DECEMBER 1914

According to the City Road Infants' School logbook, 'The Lady Mayoress Mrs Bowater, visited us on Thursday morning to thank the children for the pillows they had made for our soldiers.'

2 DECEMBER 1992

The official opening took place of St Thomas's Peace Garden, Bath Row, by the Very Reverend Peter Austin Berry, Provost of Birmingham Cathedral. The gardens are based on designs produced by three pupils of Lea Mason School and the City Council. The church of St Thomas was bombed in December 1940.

OFFICIAL OPENING OF

ST. THOMAS'S

PEACE GARDEN

BATH ROW
BIRMINGHAM B15

At 10:30am
On Wednesday 2nd December 1992

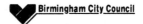
Birmingham City Council

3 DECEMBER 1890
The Workhouse Management Committee decided to, 'allow the paupers to decide whether they would have beer or temperance drinks in addition to the ordinary fare on Christmas Day.'

4 DECEMBER 1998
Clare Short MP officially opened the final phase of the Gilby Road development scheme.

5 DECEMBER 1941
According to the St Peter's School logbook, 'The weather this week has been dreadful. The city was enveloped in a dense fog on Tuesday so that day's attendance was poor. There have been fogs all week but none so severe as the one on Tuesday.'

6 DECEMBER 1964
Holloway Circus underpass was opened to outgoing traffic for the first time.

7 DECEMBER 1859
The Watch Committee approved plans for the Ladywood police station and 'the architect was instructed to advertise for tenders to erect the station.' Architects submitted twelve designs.

8 DECEMBER 1908
According to the Camden Street Girls' School logbook, 'Brookfield's girls attended for cookery. After demonstration on "Toad in the Hole" girls made the same dish without the help or direction from teachers. Results – fairly good.'

9 DECEMBER 1992
Highways Committee councillor Matt Redmond, with help from Santa and children from Brookfield School, opened the final section of the Middle Ring Road between Icknield Street and New John Street.

10 DECEMBER 1871
This date marked the death of James Baldwin, paper bag manufacturer, who had a large mill on Sherborne/Morville Street. He became Lord Mayor and Alderman in Birmingham. 'He finished a practically useful life, regretted by many.'

11 DECEMBER 1936
According to the St Peter's School logbook:

This has been a hectic week in every sense of the word. The country and Empire has been on tenterhooks wondering what would be the outcome of the announcement [that] His Majesty intends getting married. Every special newspaper has been bought; wireless news has been in demand, while every person has chatted to his neighbours on the

present state of things. Later in the week, the BBC announced "The King has abdicated". Two children represented the school at the Royal Proclamation read in Victoria Square at 12.00 p.m. The Duke of York has ascended the throne George VI.'

11/12 DECEMBER 1940

A thirteen-hour air raid lead to the destruction of St Thomas's Church in Lee Bank. Here it is pictured after the clean-up had taken place.

12 DECEMBER 2001

The *Carl Chinn Show* on BBC Radio WM was broadcast live from Ladywood Community Centre to celebrate the launch of the Ladywood History Group's newspaper the *Brew 'Us Bugle.*

13 DECEMBER 1973

The Barford Primary School logbook records that, 'The infants lead by Miss Forster, gave a Christmas concert for the parents "The Spirit of Christmas" supported by the Brass Band and junior choir.'

14 DECEMBER 1988

The Brasshouse opened on Broad Street following a six-month restoration programme.

15 DECEMBER 1905

According to the Nelson Street School logbook, 'School closed p.m. so that the teachers might prepare the room for a jumble sale to be held in the evening in order to raise funds for a school Christmas treat.'

16 DECEMBER 2007

The demolition of Clayton House, one of three blocks on the Monument Road side of Chamberlain Gardens, was underway. It was nearly three years later before an adjacent block was demolished leaving Balfour House derelict and also in need of demolition.

17 DECEMBER 1996

Demolition began on the maisonette blocks at Rickman Drive in Lee Bank. This was the first phase of clearing 305 council flats and maisonettes.

18 DECEMBER 1901

David Lloyd George visited the Town Hall, but not for long! He was an outspoken supporter of the Boer cause in South Africa and the majority of the audience were anti-Boer. The Town Hall was stoned, windows were smashed and Lloyd George escaped disguised as a policeman and marched up Broad Street to hide in Ladywood police station near Five Ways.

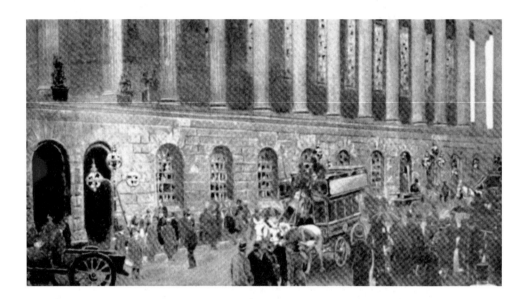

19 DECEMBER 1935

The annual Christmas party was held at Osler Street Boys' School. The *Osmag* school magazine reported, 'after tea, a concert took place in the Hall. Oranges, sweets and novelties were distributed to 313 scholars. In this connection we are grateful to the *Birmingham Mail*, Messrs Canning & Wildblood, Messrs Belliss & Morcom, and all those good people who assisted us in our recent jumble sale.'

20 DECEMBER 1923

The Palais de Danse issued a souvenir of the third anniversary of the building. It was described as 'the sensation of the Midlands – a building that is twice daily the scene of the best dancing at the lowest imaginable rates of admission.'

21 DECEMBER 1883

The publication *Building News* reproduced this fantastic sketch of the Church of The Redeemer. It stood at the junction of Hagley Road and Wyndham Road. The church has now been demolished and has been replaced nearby with a building that lacks the architectural quality of the original church.

22 DECEMBER 1924

Eighty parents attended the 'breaking up party' at Osler Street Boys' School. 'The school was gaily decorated with festoons of coloured paper, Chinese lanterns, balloons of all shades and branches of "cherry blossom".'

23 DECEMBER 1914

The St Peter's School logbook records that, 'This afternoon prizes will be distributed to the scholars – the children in the four lower classes will each receive toys and all the children will have packets of sweets.'

24 DECEMBER 2000

Hickman's greengrocery business on St Vincent Street West closed. The Hickman family ran the business in various locations across Ladywood for over ninety years. Ralph Hickman said, 'I'm sad that what was a successful business has finally been brought to its knees by what some people might call progress and different shopping habits.'

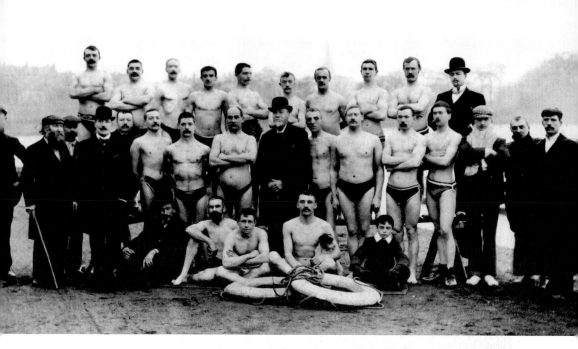

(George Brown)

25 DECEMBER 1902

Swimmers from the All the Year Round Swimming Club held their annual Christmas morning dip in Edgbaston Reservoir.

26 DECEMBER 1927

The Crown Cinema opened on Icknield Port Road.

27 DECEMBER 1993

Former Ladywood School footballer Frankie Bennett scored his first, and last, goal in professional football in Southampton's 3–1 win against Chelsea.

Come Christmas Shopping...

at the **CO·OP**
and save the dividend
BIRMINGHAM CO-OPERATIVE SOCIETY LIMITED

It's all at the Co-op in December 1957.

28 DECEMBER 1896

A lioness escaped from a menagerie in Bingley Hall. She attacked a horse and was shot while devouring it.

29 DECEMBER 1958

The Vesper Bell pub on Blythe Street closed. The name came from the Vespers held at nearby Oratory church.

30 DECEMBER 1961

A train leaving Monument Lane station overshot a signal and demolished Sheepcote Lane signal-box during exceptionally bad weather that was described as the worst since the winter of 1947. The signalman was flung under a shower of falling debris and signals controlling the main Birmingham to Wolverhampton line were cut. The engine was reversing in a shunting operation and jumped the points, crashing into the box. The signalman, Bill Russell, crawled out from the wreckage suffering from shock.

Davenport's magazine *Malt & Hops*, Christmas issue, 1945.

Season's Greetings

BIRMINGHAM CHILDREN'S HOSPITAL

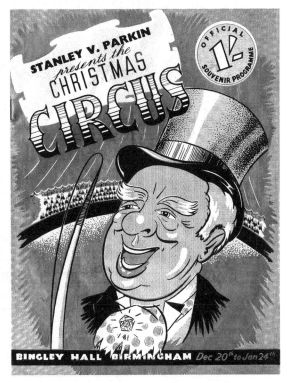

Noel Road at Monument Road, December 2010.

A circus at Bingley Hall, December 1947.

A butcher's shop on the corner of Great Colmore Street all decked out for festive sales.

31 DECEMBER 1975

According to the Barford Primary School logbook, 'The band assembled with the choir, in school, to practice for a concert to be given by them at the Open day of the new National Exhibition Centre at Bickenhill on Saturday January 3rd 1976.'

156

Acknowledgements

Thanks must go to many Ladywood people past and present, for their help during the compilation of this book, particularly Anthony Spettigue, Albert Trapp, Liz Murphy, Sue Dawe, and Geraldine Price for reading through the text and for essential historical advice.

Thanks also to those who contributed photographs and memorabilia. All uncredited pictures are from the author's collection.

The author runs The Ladywood History Group, which publishes the quarterly magazine: the *Brew 'Us Bugle* magazine. More information can be obtained from The Ladywood History Group, c/o Ladywood Arts & Leisure Centre, Monument Road, Ladywood, Birmingham, B16 8TR.

Index

Also available from The History Press

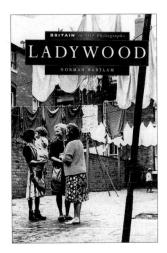

Britain in Old Photographs: Ladywood
NORMAN BARTLAM

This addition to the 'Britain in Old Photographs' series brings together a collection of black-and-white pictures spanning the late nineteenth and early twentieth centuries. Drawn from family albums, local collections and professional photographers, they show the way things were and how they have changed. Every photograph is captioned, providing names and dates where possible, revealing historical and anecdotal detail and giving life to the scenes and personalities captured through the camera lens. Bringing together all aspects of daily life – celebrations and disasters, work and leisure, people and buildings – the collection should inspire memories, as well as serve as an introduction to visitors.
978 0 7509 2071 1

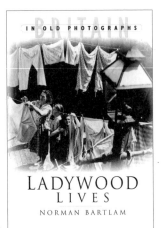

Ladywood Lives
NORMAN BARTLAM

In this follow up volume, Norman Bartlam explores streets, buildings, people, events, pastimes, industries and everyday life in Ladywood through a selection of over 300 photographs and other illustrations. This book should evoke many memories of days gone by for all those who know and love this part of Birmingham.
978 0 7509 3150 7

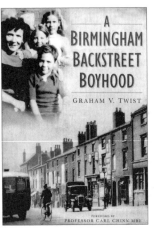

A Birmingham Backstreet Boyhood
GRAHAM V. TWIST

A Birmingham Backstreet Boyhood is a fascinating recollection of the experience of growing up in the slums of Nechells and Aston. All the harshness of daily life is remembered here by local author Graham Twist. Despite hard living conditions and a distinct lack of money, a strong community spirit prevailed and families and neighbourhoods were close-knit. The womenfolk in particular took great pride in their homes, however humble, and scrubbed their front steps and swept the areas in front of their houses religiously. In these tough times you hoped nobody noticed you going to the 'pop shop' to pawn precious valuables to get enough money to pay the rent or buy food for the family. . . .
978 0 7509 4965 1

Visit our website and discover thousands of other History Press books.

www.thehistorypress.co.uk